But is it art?

An introduction to art theory

Cynthia Freeland is Professor of Philosophy at the University of Houston. She has published on topics in the philosophy of art and film, ancient Greek philosophy, and feminist theory. She is also author of *The Naked and the Undead: Evil and the Appeal of Horror* (1999) and co-editor of *Philosophy and Film* (1995).

'So many of the questions that define us as a culture have been raised through and by the art of recent decades, that without coming to terms with our art, we can scarcely understand ourselves. Cynthia Freeland has written a very smart book, in which high philosophical intelligence is applied by a contemporary sensibility to difficult questions raised by real works of art. It immediately situates the reader where thought and action meet, and since the issues are inescapable, it should be required reading for everyone. I know of no work that moves so swiftly and with so sure a footing through the battle zones of art and society today.'

Arthur C. Danto, Columbia University

'Chapters on gender, money and the marketplace, and on the uses and abuses of "primitive" motifs in contemporary art making are models of judicious clarity.'

Publisher's Weekly

'highly informative ... Freeland's study is clearly and enthusiastically written'

Gerald Cipriani, *Journal of Art and Design Education*

'a vibrant study of a complex and contentious field of artistic endeavour and enquiry ... lucid, incisive, and thought-provoking.'

Murray Smith, *University of Kent*

'Freeland provides a unique and inclusive view of the past by discussing it from the vantage point of contemporary art.'

Lucy R. Lippard, author of *Mixed Blessings: New Art in a Multicultural America*

'the court of Louis XIV, aboriginal tourist art, and the digital revolution . . . Freeland has managed to distil theories of art, the history of aesthetics, and a selected tour of art history into a brief and eminently informative text'

Carolyn W. Korsmeyer, State University of New York

'a lively, eminently readable and remarkably wide ranging discussion of issues germane to the field of contemporary art. . . . A delight.'

Eleanor Heartney, author of *Critical Condition: American Culture at the Crossroads*

COVER ILLUSTRATION: Painter William Conger created 'Crossfire Cow' for the summer 1999 Chicago public art display CowParade. This exhibition, a successor of CULTURE IN ACTION in 1993 (discussed in Chapter 4 of this book) was the most successful public art program in the city's history. More than 300 life-sized fiberglass cows were individually decorated by recognized and outsider artists, then displayed around the city. Many were later sold in a 'cattle auction' with proceeds going to charity (to the tune of $3.4 million). Artist Conger, a Chicago-area painter and art professor, has explained that he made his cow both in fun and as a serious work with art historical references. His title alludes to the 'crossfire' in modernist and post-modernist art criticism and theory. Originating in Zurich and then moving to America with the successful Chicago installation, CowParade has gone on to become a franchise, with parades in New York, Houston, and other cities; Cow-Parade London was postponed in summer 2001 due to sensitivities concerning the Foot and Mouth epidemic.

But is it art?

AN INTRODUCTION TO ART THEORY

Cynthia Freeland

OXFORD
UNIVERSITY PRESS

OXFORD

UNIVERSITY PRESS

Great Clarendon Street, Oxford OX2 6DP

Oxford University Press is a department of the University of Oxford.
It furthers the University's objective of excellence in research, scholarship,
and education by publishing worldwide in

Oxford New York

Athens Auckland Bangkok Bogotá Buenos Aires Cape Town
Chennai Dar es Salaam Delhi Florence Hong Kong Istanbul Karachi
Kolkata Kuala Lumpur Madrid Melbourne Mexico City Mumbai Nairobi
Paris São Paulo Shanghai Singapore Taipei Tokyo Toronto Warsaw

with associated companies in Berlin Ibadan

Oxford is a registered trade mark of Oxford University Press
in the UK and in certain other countries

Published in the United States
by Oxford University Press Inc., New York

British Library Cataloguing in Publication Data

Data available

Library of Congress Cataloging in Publication Data

Data available

ISBN 0-19-210055-6 (hbk.)

3 5 7 9 10 8 6 4

ISBN 0-19-285367-8 (pbk.)

5 7 9 10 8 6 4

Typeset in New Baskerville
by RefineCatch Limited, Bungay, Suffolk
Printed in Spain by
Book Print S.L., Barcelona

To Herbert Garelick

Acknowledgements

Deepest thanks to people who read and commented on the entire manuscript: Oxford's 'Reader 3' (unveiled as Murray Smith), Jennifer McMahon, Mary McDonough, and my parents, Alan and Betty Freeland. Carolyn Korsmeyer made valuable suggestions, and Kristi Gedeon was a research assistant beyond compare—cheery, resourceful, a packhorse for heavy books! Thanks to others for generous help with the text or illustrations: Robert Wicks, Nora Laos, Weihong Kronfied, Sheryl Wilhite Garcia, Jeannette Dixon, Eric McIntyre, Lynne Brown, Rose Lange, Anne Jacobson, William Austin, Justin Leiber, and Amy Ione. My husband, Krist Bender, supplied technical assistance and artistic opinions. I am much indebted to Oxford's capable editor, Shelley Cox. Heartfelt appreciation to the guinea pigs for this text, my students in Philosophy 1361—you made a bigger difference than you suspect. A more indefinite thanks for their stimulating influence to my friends in the exciting art world of Houston. I dedicate this book to my first professor of aesthetics, Herbert Garelick, of Michigan State University.

Contents

Colour plates

Black and white illustrations

I gratefully acknowledge a small grant from the University of Houston to support image reproduction costs for this book.

1 Damien Hirst, *The Physical Impossibility of Death in the Mind of Someone Living* (1991)
 Courtesy Jay Jopling/White Cube, London. Photograph: Anthony Oliver

2 Sandro Botticelli, detail from *Birth of Venus*
 Archivi Alinari

3 Francisco Goya, *Saturn Devouring One of His Sons*
 Museo Nacional del Prado, Madrid

4 Chartres Cathedral
 Sonia Halliday Photographs

5 Versailles (engraving by Perelle)
 Bibliothèque nationale de France

6 Scene from Robert Wilson's staging of Wagner's *Parsifal*,
 Houston Grand Opera
 Jim Caldwell/Houston Grand Opera

7 Philosopher Arthur Danto pondering why Andy Warhol's stacked *Brillo Boxes* are art.
 © The Andy Warhol Foundation for the Visual Arts, Inc./ ARS, New York, DACS, London, and VPRO

8 Zen Buddhist garden in Japan
 William Herbrechtsmeier. Photograph: Revd. John K. Rogers

Introduction

This is a book about what art is, what it means, and why we value it—a book on topics in the field loosely called art theory. We will scrutinize many different art theories here: ritual theory, formalist theory, imitation theory, expression theory, cognitive theory, postmodern theory—but not in order, one by one. That would be as tedious for me to write as for you to read. A theory is more than a definition; it is a framework that supplies an orderly explanation of observed phenomena. A theory should help things make sense rather than create obscurity through jargon and weighty words. It should systematically unify and organize a set of observations, building from basic principles. But the 'data' of art are so varied that it seems daunting to try to unify and explain them. Many modern artworks challenge us to figure out why, on *any* theory, they would count as art. My strategy here is to highlight the rich diversity of art, in order to convey the difficulty of coming up with suitable theories. Theories have practical consequences, too, guiding us in what we value (or dislike), informing our comprehension, and introducing new generations to our cultural heritage.

A big problem about laying out the data for this book is that our term 'art' might not even apply in many cultures or eras. The practices and roles of artists are amazingly multiple and elusive. Ancient and modern tribal peoples would not distinguish art from artefact or ritual. Medieval European Christians did not make 'art' as such, but tried to emulate and celebrate God's beauty. In classical Japanese aesthetics, art might include things unexpected by modern Westerners, like a garden, sword, calligraphy scroll, or tea ceremony.

Many philosophers from Plato onward have proposed theories of art and aesthetics. We shall scrutinize some of them here, including the medieval colossus Thomas Aquinas, the Enlightenment's key figures David Hume and Immanuel Kant, the notorious iconoclast Friedrich Nietzsche, and such diverse twentieth-century figures as John Dewey, Arthur Danto, Michel Foucault, and Jean Baudrillard. Of course, there are also theorists in other fields who study art: from sociology, art history and criticism, anthropology, psychology, education, and more; I will refer to some of these experts as well.

One group of people with a strong focus on art are members of an association I belong to, the American Society for Aesthetics. At our annual conferences we attend lectures about art and its subfields—film, music,

painting, literature; we also do more fun things, like go to exhibitions and concerts. I have used the programme and topics from one of these conferences, held in 1997 in Santa Fe, New Mexico, as a loose organizing strategy for my chapters below. Santa Fe itself offers a kind of microcosm of the diverse arts issues and intersections I want to consider here. Nestled in the natural beauty of the desert and nearby mountains, the city boasts a surprising array of museums, both historic and modern. It is as renowned for its sleek high-rent (and high-priced) commercial galleries as for the many artisans on the plaza selling their wares at bargain rates. The city illustrates the complex history of today's America, mingling a constant influx of tourists and newcomers with its Spanish colonial heritage, enriched by Native Americans from nearby pueblos, with their marvellous pottery, weavings, fetishes, and kachina dolls.

In approaching our study of art's diversity, I warn you that I have chosen shock tactics, for I will begin in the rather grisly present-day world of art, dominated by works that speak of sex or sacrilege, made with blood, dead animals, or even urine and faeces (Chapter 1). My aim is to defuse the shock a little by linking such work with earlier traditions, to demonstrate that art has not always been about the beauty of the Parthenon or a Botticelli Venus. If you make it through the first

chapter, you will accompany me as we backtrack through art's history (Chapter 2), before circuiting the globe in pursuit of art's diverse manifestations (Chapter 3). Theories will be presented when it seems appropriate, in response to the data we encounter from a variety of cultures and eras.

People in the field of aesthetics do more than try to define what art is. We also want to explain why it is valued, considering how much people pay for it and where art is collected and displayed—for example, museums (Chapter 4). What can we learn by examining where art is exhibited, how, and how much it costs? Art theorists also ponder questions about artists: who are they, and what makes them special? Why do they do the sometimes odd things they do? Recently this has led to intense debate about whether intimate facts concerning artists' lives, such as their gender and sexual orientation, are relevant to their art (Chapter 5).

Among the hardest problems an art theory faces are questions about how to settle art's meaning through interpretation (Chapter 6). We will consider whether an artwork has 'a' meaning, and how theorists have tried to capture or explain it—whether by studying artists' feelings and ideas, their childhood and unconscious desires, or their brains(!). Finally, of course, we all want to know what lies ahead for art in the

twenty-first century. In the age of the Internet, CD-ROM, and World Wide Web (Chapter 7), we can visit museums 'virtually' without the aggravation of crowds (let alone the cost of an air ticket)—but what do we miss when we do that? And what kinds of new art are fostered in the new media?

I hope this overview indicates the range and challenge of the issues that make the study of art so intriguing. It seems that art always has been and always will be important to humans; and the things artists do will probably keep puzzling us as well as providing insights and joy. Let's begin our plunge into art theory.

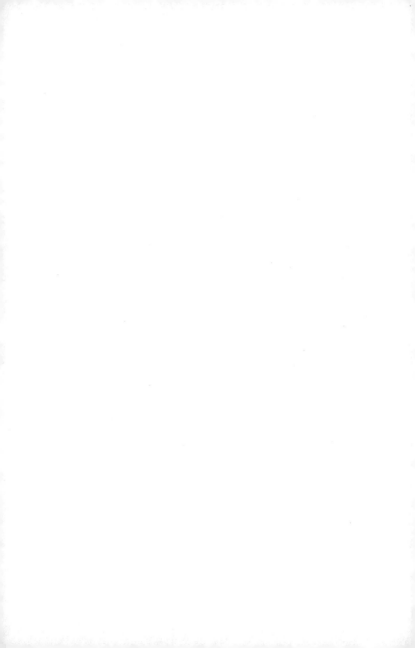

1

Blood and beauty

A rude awakening at the Aesthetics Society

On one morning at our American Society for Aesthetics conference, a small group of people straggled into a room at 9 a.m., to be jolted awake by slides and videos on 'The Aesthetics of Blood in Contemporary Art'. We saw the blood of Mayan kings and of aboriginal Australian youths at initiation ceremonies. We saw blood poured over statues in Mali and spurting from sacrificial water buffaloes in Borneo. Some of the blood was more recent and closer to home. Buckets of blood drenched performance artists and droplets of blood oozed from the lips of Orlan, who is redesigning herself through plastic surgery to resemble famous beauties in Western art. Something was guaranteed to disgust almost everyone there.

Why has blood been used in so much art? One reason is that it has interesting similarities to paint. Fresh blood

has an eye-catching hue with a glossy sheen. It will stick to a surface, so you can draw or make designs with it (on the skin of the Aborigine youths, its shimmering cross-hatched patterns evoke the archetypal era of the 'Dream Time'). Blood is our human essence—Dracula sucks it up as he creates the undead. Blood can be holy or noble, the sacrificial blood of martyrs or soldiers. Spots of blood on sheets indicate the loss of virginity and passage to adulthood. Blood can also be contaminated and 'dangerous', the blood of syphilis or Aids. Obviously, blood has a host of expressive and symbolic associations.

Blood and ritual

But does blood in kooky modern (urban, industrial, First World) art mean what it does in 'primitive' rituals? Some people advocate a theory of art as ritual: ordinary objects or acts acquire symbolic significance through incorporation into a shared belief system. When the Mayan king shed blood before the multitude in Palenque by piercing his own penis and drawing a thin reed through it three times, he exhibited his shamanistic ability to contact the land of the undead. Some artists seek to recreate a similar sense of art as ritual.

Diamanda Galás fuses operatic wizardry, light shows, and glistening blood in her *Plague Mass*, supposedly to exorcise pain in the era of Aids. Hermann Nitsch, the Viennese founder of the Orgies Mystery Theatre, promises catharsis through a combination of music, painting, wine-pressing, and ceremonial pouring of animal blood and entrails. You can read all about it on his Web site at www.nitsch.org.

Such rituals are not altogether alien to the European tradition: there is a lot of blood in its two primary lineages, the Judaeo-Christian and the Greco-Roman. Jahweh required sacrifices as parts of His covenant with the Hebrews, and Agamemnon, like Abraham, faced a divine command to slit the throat of his own child. The blood of Jesus is so sacred that it is symbolically drunk to this day by believing Christians as promising redemption and eternal life. Western art has always reflected these myths and religious stories: Homeric heroes won godly favour by sacrificing animals, and the Roman tragedies of Lucan and Seneca piled up more body parts than Freddy Krueger in *A Nightmare on Elm Street*. Renaissance paintings showed the blood or lopped heads of martyrs; Shakespeare's tragedies typically concluded with swordplay and stabbings.

A theory of art as ritual might seem plausible, since art can involve a gathering guided by certain aims,

producing symbolic value by the use of ceremonies, gestures, and artefacts. Rituals of many world religions involve rich colour, design, and pageantry. But ritual theory does not account for the sometimes strange, intense activities of modern artists, as when a performance artist uses blood. For participants in a ritual, clarity and agreement of purpose are central; the ritual reinforces the community's proper relation to God or nature through gestures that everyone knows and understands. But audiences who see and react to a modern artist do not enter in with shared beliefs and values, or with prior knowledge of what will transpire. Most modern art, in the context of theatre, gallery, or concert hall, lacks the background reinforcement of pervasive community belief that provides meaning in terms of catharsis, sacrifice, or initiation. Far from audiences coming to feel part of a group, sometimes they get shocked and abandon the community. This happened in Minneapolis when performance artist Ron Athey, who is HIV-positive, cut the flesh of a fellow performer on stage and then hung blood-soaked paper towels over the audience, creating a panic. If artists just want to shock the bourgeoisie, it becomes pretty hard to distinguish the latest kind of art that gets written up in *Artforum* from a Marilyn Manson performance that includes Satanic rituals of animal sacrifice on stage.

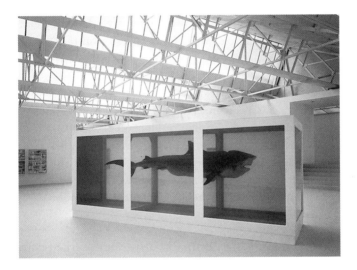

1 'Young British artist' Damien Hirst won fame with his animals in vitrines, like this huge shark in *The Physical Impossibility of Death in the Mind of Someone Living* (1991).

The cynical assessment is that blood in contemporary art does not forge meaningful associations, but promotes entertainment and profit. The art world is a competitive place, and artists need any edge they can get, including shock value. John Dewey pointed out in *Art as Experience*, in 1934, that artists must strive for novelty in response to the market:

> Industry has been mechanized and an artist cannot work mechanically for mass production. . . . Artists find it incumbent . . . to betake themselves to their work as an isolated means of 'self-expression.' In order not to cater to the trend of economic forces, they often feel obliged to exaggerate their separateness to the point of eccentricity.

Damien Hirst, the 'Britpack' artist who sparked controversy in the 1990s by displaying macabre high-tech exhibits of dead sharks, sliced cows, or lambs in vitrines of formaldehyde, has parlayed his notoriety into success with his popular Pharmacy restaurant in London. It is hard to imagine how Hirst's tableaux of rotting meat (complete with maggots) helped his image in the food business—but fame works in mysterious ways.

Some of the most infamous art of recent decades became controversial because of its startling presentation of human bodies and body fluids. At the 1999

Sensation exhibit at the Brooklyn Museum of Art, the most controversial artwork ('Virgin Mary' by Chris Ofili) even used elephant dung. Controversy erupted about funding of the US National Endowment for the Arts (NEA) in the late 1980s after bodies were penetrated and exposed, as blood, urine, and semen became newly prominent in art. Images like Andres Serrano's *Piss Christ* (1987) and Robert Mapplethorpe's *Jim and Tom, Sausalito* (1977) (which showed one man urinating into another man's mouth) became key targets for critics of contemporary art.

It is no accident that this controversial work was about religion, as well as body fluids. Symbols of pain and suffering that are central to many religions can be shocking when dislocated from their community. If they mix with more secular symbols, their meaning is threatened. Artwork that uses blood or urine enters into the public sphere without the context of either well-understood ritual significance or artistic redemption through beauty. Probably the critics of modern art are nostalgic for beautiful and uplifting art like the *Sistine Chapel*. There, at least the bloody scenes of martyred saints or torments of sinners at the Last Judgement were wonderfully painted, with a clear moral aim (just as the horrors of ancient tragedy were depicted through inspiring poetry). Similarly, some critics of contemporary

art feel that if a body is to be shown nude, it should resemble Botticelli's *Venus* or Michelangelo's *David*. These critics seemed unable to find either beauty or morality in Serrano's infamous photograph *Piss Christ* (see Plate I). Senator Jesse Helms summed it up, 'I do not know Mr Andres Serrano, and I hope I never meet him. Because he is not an artist, he is a jerk.'

Controversies about art and morality are not new, of course. The eighteenth-century philosopher David Hume (1711–1776) also dealt with hard questions about morality, art, and taste, a key concern of his era. It is likely that Hume would not have approved of blasphemy, immorality, sex, or the use of body fluids as appropriate in art. He felt artists should support Enlightenment values of progress and moral improvement. The writings of Hume and his successor Immanuel Kant (1724–1804) form the basis of modern aesthetic theory, so I turn to them next.

Taste and beauty

The term 'aesthetics' derives from the Greek word for sensation or perception, *aisthesis*. It came into prominence as a label for the study of artistic experience (or sensibility) with Alexander Baumgarten (1714–1762).

The Scottish philosopher David Hume did not use this term but spoke of 'taste', a refined ability to perceive quality in an artwork. 'Taste' might seem completely subjective—we all know the saying 'there's no accounting for taste'. Some people have favourite colours and desserts, just as they prefer certain kinds of automobiles or furniture. Isn't art just like this? Perhaps you prefer Dickens and Fassbinder, while I prefer Stephen King and *Austin Powers*; how can you prove that your taste is better than mine? Hume and Kant both struggled with this problem. Both men believed that some works of art really *are* better than others, and that some people have better taste. How could they account for this?

The two philosophers took different approaches. Hume emphasized education and experience: men of taste acquire certain abilities that lead to agreement about which authors and artworks are the best. Such people, he felt, eventually will reach consensus, and in doing so, they set a 'standard of taste' which is universal. These experts can differentiate works of high quality from less good works. Hume said men of taste must 'preserve minds free from prejudice', but thought no one should enjoy immoral attitudes or 'vicious manners' in art (his examples included Muslim and Roman Catholic art marred by over-zealousness). Sceptics now criticize the narrowness of this view, saying

that Hume's taste-arbiters only acquired their values through cultural indoctrination.

Kant too spoke about judgements of *taste* but he was more concerned with explaining judgements of *Beauty*. He aimed to show that good judgements in aesthetics are grounded in features of artworks themselves, not just in us and our preferences. Kant tried to describe our human abilities to perceive and categorize the world around us. There is a complex interplay among our mental faculties including perception, imagination, and intellect or judgement. Kant held that in order to function in the world to achieve our human purposes, we label much of what we sense, often in fairly unconscious ways. For example, we modern Westerners recognize round flat things out in the world, and we categorize some of these as dinner plates. Then we use them to eat our meals. Similarly, we recognize some things as food and others as potential threats or marriage partners.

It is not easy to say how we categorize things like red roses as beautiful. The beauty of the roses is not out there in the world, as the roundness and flatness are in the plates. If it were, then we would not get into so many disagreements of taste. And yet there is *some* sort of basis for claiming that the roses are beautiful. After all, there is quite a lot of human agreement that roses are

beautiful and that cockroaches are ugly. Hume tried to resolve this problem by saying that judgements of taste are 'intersubjective': people with taste tend to agree with each other. Kant believed that judgements of beauty were universal and grounded in the real world, even though they were not actually 'objective'. How could this be?

Kant was a kind of predecessor to modern scientific psychologists who study judgements of beauty by observing infant preferences for faces, tracking viewers' eye movements, or hooking up artists to do magnetic resonance images (MRIs)—see also below in Chapter 6. Kant noted that we typically apply labels or concepts to the world to classify sensory inputs that suit a purpose. For example, when I find a round flat thing in the dishwasher that I recognize as a plate, I put it away in the cupboard with other plates, not in the drawer with spoons. Beautiful objects do not serve ordinary human purposes, as plates and spoons do. A beautiful rose pleases us, but not because we necessarily want to eat it or even pick it for a flower arrangement. Kant's way of recognizing this was to say that something beautiful has 'purposiveness without a purpose'. This curious phrase needs to be further unpacked.

Beauty and disinterestedness

When I perceive the red rose as beautiful, this is not quite like putting it into my mental cupboard of items labelled 'beauty'—nor do I just throw the disgusting cockroach into my mental trash can of 'ugly' items. But features of the object almost force me ('occasion me') to label it as I do. The rose might have its own purpose (to reproduce new roses), but that is not why it is beautiful. Something about its array of colours and textures prompts my mental faculties to feel that the object is 'right.' This rightness is what Kant means by saying that beautiful objects are purposive. We label an object beautiful because it promotes an internal harmony or 'free play' of our mental faculties; we call something 'beautiful' when it elicits this pleasure. When you call a thing beautiful, you thereby assert that everyone ought to agree. Though the label is prompted by a subjective awareness or feeling of pleasure, it supposedly has objective application to the world.

Kant warned that enjoyment of beauty was distinct from other sorts of pleasure. If a ripe strawberry in my garden has a ruby colour, texture, and odour that are so delightful that I pop it into my mouth, then the judgement of beauty has been contaminated. In order to appreciate the beauty of this strawberry, Kant thinks

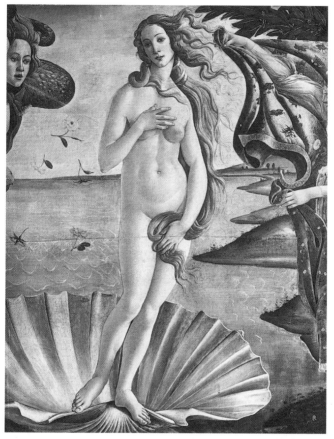

2 Many people believe art should be beautiful and nudes should be Greek gods and goddesses, like Sandro Botticelli's Venus from *Birth of Venus*.

our response has to be disinterested—independent of its purpose and the pleasurable sensations it brings about. If a viewer responds to Botticelli's *Venus* with an erotic desire, as if she is a pinup, he is actually not appreciating her for her beauty. And if someone enjoys looking at a Gauguin painting of Tahiti while fantasizing about going on vacation there, then they no longer have an aesthetic relation to its beauty.

Kant was a devout Christian, but he did not think God played an explanatory role in theories of art and beauty. To make beautiful art requires human *genius*, the special ability to manipulate materials so that they create a harmony of the faculties causing viewers to respond with distanced enjoyment. (We will look further at an example, Le Nôtre's gardens at Versailles, in the next chapter.) In summary, for Kant the aesthetic is experienced when a sensuous object stimulates our emotions, intellect, and imagination. These faculties are activated in 'free play' rather than in any more focused and studious way. The beautiful object appeals to our senses, but in a cool and detached way. A beautiful object's *form* and design are the key to the all-important feature of 'purposiveness without a purpose'. We respond to the object's rightness of design, which satisfies our imagination and intellect, even though we are not evaluating the object's purpose.

Kant's legacy

Kant developed an account of beauty and of our responses to it. This was not all there was to his theory of art, nor did he insist that all art must be beautiful. But his account of beauty became central to later theories that emphasized the notion of an aesthetic response. Many thinkers held that art should inspire a special and disinterested response of distance and neutrality. Kant's view of beauty had ramifications well into the twentieth century, as critics emphasized the aesthetic in urging audiences to appreciate new and challenging artists like Cézanne, Picasso, and Pollock. Art writers such as Clive Bell (1881–1964), Edward Bullough (1880–1934), and Clement Greenberg (1909–1994) adopted varying views and wrote for different audiences, but they shared attitudes in common with Kant's aesthetics. Bell, for instance, writing in 1914 emphasized 'Significant Form' in art rather than content. 'Significant Form' is a particular combination of lines and colours that stir our aesthetic emotions. A critic can help others see form in art and feel the resulting emotions. These emotions are special and lofty: Bell spoke of art as an exalted encounter with form on Art's 'cold white peaks' and insisted that art should have nothing to do with life or politics.

Bullough, a literature professor at Cambridge, wrote a famous essay in 1912 that described 'psychical distance' as a prerequisite for experiencing art. This was a somewhat updated account of Kant's notion of beauty as the 'free play of imagination'. Bullough argued that sexual or political subjects tend to block aesthetic consciousness:

> ... [E]xplicit references to organic affections, to the material existence of the body, especially to sexual matters, lie normally below the Distance-limit, and can be touched on by Art only with special precautions.

Obviously, the works of Mapplethorpe and Serrano would be the furthest thing from Bullough's mind as candidates for the label of 'Art'.

And Greenberg, who was Pollock's major champion, celebrated form as the quality through which a painting or sculpture refers to its medium and to its own conditions of creation. Seeing what is in a work or what it 'says' is not the point; the astute viewer (with 'taste') is meant to see the work's very flatness or its way of dealing with paint as paint.

There are important rivals to this account of art as Significant Form; I will consider some later in this book. But the views of Enlightenment thinkers like Kant and Hume still reverberate today in discussions of quality,

morality, beauty, and form. Art experts testified at the obscenity trial of the Cincinnati gallery that exhibited Mapplethorpe's work that his photographs counted as art because of their exquisite formal properties, such as careful lighting, classical composition, and elegant sculptural shapes. In other words, Mapplethorpe's work fulfilled the 'beauty' expectation required of true art—even nudes with huge penises should be viewed with dispassion as cousins of Michelangelo's *David*.

But how did proponents defend Serrano's *Piss Christ*? This photograph was highly offensive to many people. Serrano has made other difficult photographs as well: his *Morgue* series zeroes in on gruesome dead bodies. Another disturbing image, *Heaven and Hell*, shows a complacent man (actually the artist Leon Golub) dressed in red as a Cardinal of the Church standing beside the nude and bloody torso of a hanging woman. *Cabeza de Vaca* features the decapitated head of a cow that unnervingly seems to peek at the viewer. Taking on the challenge of explaining such work, critic Lucy Lippard wrote about Serrano in *Art in America* in April 1990. We can look at her review to see how an art theorist talks about difficult contemporary art. Because she emphasizes the art's content and Serrano's emotional and political commentary, Lippard represents a

different tradition from the aesthetic formalism of Kant's twentieth-century successors.

Defending Serrano

Lippard's defence of Serrano uses a three-pronged analysis: she examines (1) his work's *formal* and *material* properties; (2) its *content* (the thought or meaning it expresses); and (3) its *context*, or place in the Western art tradition. Each step is important, so let us review them in more detail.

First, Lippard describes how a picture like *Piss Christ* looks and was made. Many people were so disgusted by the title that they could not bear to look at the work; others saw it only in small black and white reproductions. My students thought that the image showed a crucifix in a toilet or in a jar of urine—neither of which is true. The actual photograph looks different from a small image in a magazine or book (like the one reproduced here)—just as aficionados will say that an Ansel Adams original has qualities no reproduction can convey. *Piss Christ* is *huge* for a photograph: 60 by 40 inches (roughly five by three feet). It is a Cibachrome, a colour photograph that is glossy and rich in its colours. This is a difficult medium to work with because the

prints' glassy surfaces are easily ruined by the touch of a fingertip or the slightest speck of dust.

Though the photograph was made using (the artist's own) urine and has 'piss' in its title, the urine is not recognizable as such. The crucifix looks large and mysterious, bathed in golden fluid. Lippard writes:

> *Piss Christ*—the object of censorial furor—is a darkly beautiful photographic image. . . . The small wood-and-plastic crucifix becomes virtually monumental as it floats, photographically enlarged, in a deep golden, rosy glow that is both ominous and glorious. The bubbles wafting across the surface suggest a nebula. Yet the work's title, which is crucial to the enterprise, transforms this easily digestible cultural icon into a sign of rebellion or an object of disgust simply by changing the context in which it is seen.

Serrano's title is (no doubt intentionally) jarring. It seems we are meant to be torn between being shocked and musing over an image that is mysterious, perhaps even reverential.

With regard to the artwork's 'material' qualities, Lippard explains that Serrano does not regard body fluids as shameful but as natural. Perhaps his attitude stems from his cultural background: Serrano is a member of a minority group in the United States (he is part Honduran and part Afro-Cuban). Lippard points out

that in Catholicism, bodily suffering and body fluids have been depicted for millennia as sources of religious power and strength. Vials in churches hold fabric, bits of blood, bones, and even skulls that commemorate saints and stories of miracles. Instead of being regarded with panic or horror, these relics are reverenced. Perhaps Serrano grew up with and looks back upon a somewhat more vital kind of encounter with the spiritual in fleshly form than what he sees in the culture around him. The artist wanted to condemn the way that culture pays only lip service to a religion without truly endorsing its values.

It is hard to prevent a discussion of form and materials from spilling over into a discussion of content. We have already begun to take up the second prong of Lippard's article by considering the artist's intended *meaning*. Serrano told Lippard about his religious concerns:

> I'd been doing religious pictures for two or three years before I realized I had done a lot of religious pictures! I had no idea I had this obsession. It's a Latino thing, but it's also a European thing, more so than an American thing.

Serrano claims that his work was not done to denounce religion but its *institutions*—to show how our con-

temporary culture is commercializing and cheapening Christianity and its icons. Lippard supports this by noting that the artist produced a group of similar works in 1988 (*Piss Deities*) showing other famous icons of Western culture afloat in urine, ranging from the Pope to Satan. Analysis of the content or meaning of other disturbing works, such as *Heaven and Hell*, requires the further step of talking about Serrano's *context*.

The third point of Lippard's three-pronged defence of Serrano then goes beyond discussing his work's formal properties or themes to address his inspirations and artistic antecedents. Serrano speaks of his 'strong ties to the Spanish tradition of art, which can be both violent and beautiful', mentioning in particular the painter Francisco Goya and filmmaker Luis Buñuel. This art-historical context is interesting and important, but complicated. I will zero in on just the first of these comparisons and look at Goya's works in more detail, to assess whether Lippard has used a reasonable strategy in linking Serrano's controversial contemporary art to this prominent and respected Spanish predecessor.

Goya—a precursor?

Francisco Goya y Lucientes (1746–1828), a contemporary of both Hume and Kant, was a supporter of modern

democratic values. His lifetime spanned the American and French Revolutions and the terrors of the French and Spanish Peninsular War. His place as a genius in the canon of Western art is secure. Appointed official painter to the King of Spain in 1799, Goya is well known for his images of noblemen in gold-tasselled uniforms and ladies in brilliant satins and silks. He painted familiar Spanish genre scenes like bullfights; but sex and politics were never far from his art. His enticing but controversial *Naked Maja* brought him to the attention of the Spanish Inquisition.

Goya witnessed tumultuous political events when Napoleon's army invaded Spain; he painted many scenes of battles, revolts, and assassinations, such as his famous *The Executions of May 3, 1808*, where innocent civilians are gunned down by an inexorable, faceless row of Napoleon's soldiers. At the centre stands a man, arms outflung in mortal terror a moment before the bullets will hit. Another man lies dead in a pool of blood. Monks hide their faces in horror at the massacre. Some would say this scene of death is not so unusual in Western art. The artist drew on religious imagery of martyred saints to depict new political martyrs.

Goya's art made people confront the dire possibilities of human nature in moments of extreme crisis. In his

Caprichos series he created savage images of moral depravity, scenes set in brothels and caricatures that showed people as chickens and doctors as donkeys. The painter defended his aims (speaking of himself in the third person):

> [C]ensoring human errors and vices—although it seems the preserve of oratory and poetry—may also be a worthy object of painting. As a subject appropriate to his work, he has selected from the multitude of stupidities and errors common to every civil society, and from the ordinary obfuscations and lies condoned by custom, ignorance, or self-interest, those he has deemed most fit to furnish material for ridicule, and at the same time to exercise the author's imagination.

Some would say that Goya's moral perspective differentiates him from a modern artist like Serrano. Whereas (some think) Serrano sought sensationalism or was too ambiguous about the meaning of images like *Piss Christ* and *Heaven and Hell,* Goya's position seems clear and defensible. But this contrast is not so easy to maintain. Since Goya supported the French Revolution, it is assumed he is a creature of the Enlightenment, sharing its values with men like Hume and Kant. But Goya witnessed terrible atrocities, with violence and retaliation on both sides during the invasion of Spain.

He evoked these scenes repeatedly in disturbing works in his series of *Los desastres de la Guerra* (*The Horrors of War*) (1810–1814). Goya makes it plain that there were no moral winners in this war: a French soldier lounges while a peasant hangs, but then a peasant hacks away at a helpless man in uniform. Goya's sketches seem to reject Enlightenment hopes of progress and human improvement and approach moral nihilism in endless gruesome scenes of beheadings, lynchings, spearings, spikings, and more.

Even beyond this political despair, the artist seems to have plunged into bleak hopelessness after a horrific illness left him deaf. His *Black Paintings*, done on walls in a room of his own home, are among the most disturbing in all of art history. *Saturn Devouring One of His Sons* depicts the graphic and bloody dismemberment of a cannibalistic infanticide. Other images, though less bloody and violent, are even more disturbing. His *Colossus* sits huge and menacing upon the land like an enormous Cyclopean monster. *Dog Buried in the Sand* is a pitiful animal overwhelmed by brutal forces of nature, alone and despairing. It is impossible to view these late works of Goya with aesthetic distance. Are they the product of a diseased mind, a sick imagination, a temporary lapse of sanity? It would be sheer dogma to deny that Goya has stopped being a good artist because

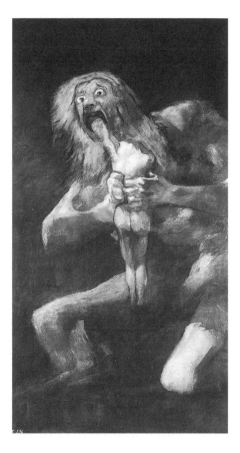

3 Francisco Goya's *Saturn* alludes to ancient Greek mythology, in a disturbing image open to both political and personal interpretations.

such works are painful or because their moral point seems obscure.

This brief art historical detour enables us to draw a positive conclusion about Serrano's claim to regard Goya as a forebear whose images combine beauty with great violence. Remember that such a comparison is a part of Lucy Lippard's defence of Serrano's often troubling images. Of course, a detractor might say that Goya is different from Serrano because his artistic ability was greater, and because he depicted violence not to sensationalize it or to shock people but precisely in order to condemn it. Each point has problems. It is going to be hard to compare any twentieth-century artist to a 'Great Master' from the past like Goya. We are not in a position to know the ultimate judgement of history; and not being a Goya does not mean that someone altogether lacks artistic ability. Lippard has argued, reasonably, that Serrano's work exhibits skill, training, thought, and careful preparation.

And second, it is quite possible that Goya is not asserting a morally uplifting message in all his works, but saying instead that human nature is dreadful. A lament can be a legitimate message in art, even when delivered with shocking content that prevents us from maintaining our aesthetic distance. Perhaps Serrano meant to insult established religion, but this could stem from a moral

motivation. When he photographs corpses it may not be to wallow in their decay but to offer anonymous victims some moments of human sympathy. Such an aim would confirm the continuity between him and his distinguished artist predecessor Goya.

Conclusion

Artwork in recent years has incorporated a lot of horror. Photographers have shown corpses or the grisly severed heads of animals, sculptors have displayed rotting meat with maggots, and performance artists have poured out buckets of blood. I could have mentioned other highly successful artists with similar subjects: the tortured bodies of Francis Bacon's paintings (which we will consider in Chapter 6), or the representations of Nazi ovens in Anselm Kiefer's huge dark canvases.

So far I have raised doubts about two theories of art. The theory of art as communal ritual fails to account for the value and effects of much contemporary art. The experience of walking into a spacious, well-lit, and air-conditioned gallery or a modern concert hall may have its own ritualistic aspects, but ones completely unlike those achieved by the sober participants with shared transcendent values at occasions like those I mentioned

at the start of this chapter, such as a Mayan or Australian Aboriginal tribal gathering. It seems unlikely we are seeking to contact the gods and higher reality, or appease spirits of our ancestors.

But neither does recent art seem defensible within an aesthetic theory like Kant's or Hume's that rests upon Beauty, good taste, Significant Form, detached aesthetic emotions, or 'purposiveness without a purpose'. Many critics do praise the beautiful compositions of Mapplethorpe's photographs and the elegant stylization of Hirst's gleaming vitrines with suspended animals inside. But even if they find the work beautiful, its startling content demands consideration. Perhaps disinterestedness has some small role in approaching difficult art by enabling us to try harder to look at and understand something that seems very repugnant. But the work's content is also very crucial, as I think Hirst's titles indicate—he confronts viewers directly with tough issues, as in the shark piece, entitled *The Physical Impossibility of Death in the Mind of Someone Living.*

By pointing back to works of an important artist from the past, Goya, I have argued that contemporary ugly or shocking art like Serrano's has clear precedents in the Western European canon. Art includes not just works of formal beauty to be enjoyed by people with 'taste', or works with beauty and uplifting moral messages, but

also works that are ugly and disturbing, with a shatter-ingly negative moral content. How that content is to be interpreted remains a matter for more discussion below.

Paradigms and purposes

A virtual tour

Contemporary artists who create work using blood, urine, maggots, and plastic surgery are successors of past artists who took sex, violence, and war as their subjects. Such work flouts the two theories of art that we considered in Chapter 1: it does not foster unity in communal religious rituals, nor does it promote distanced experience of aesthetic qualities like Beauty and Significant Form. What theory applies to such difficult work?

Philosophers have pondered distinct works in saying what 'Art' is or should be. In this chapter I will illustrate the diversity of art's forms and roles in the Western world, by leading a virtual tour through five periods. We will move from fifth-century BCE Athens to medieval Chartres, then on to the formal gardens of Versailles (1660–1715), and the premiere of Richard Wagner's

opera *Parsifal*, in 1882. We conclude in 1964, with Andy Warhol's *Brillo Box*, and a review of recent theories about art.

Tragedy and imitation

Ancient discussions of tragedy introduced one of the most persistent of all theories of art, the imitation theory: art is an imitation of nature or of human life and action. Classical tragedy began in Athens in the sixth century BCE as part of a spring celebration of Dionysus, god of the grape harvest, dancing, and drinking. In Greek mythology, he had been torn apart by Titans but was always regenerated, like the vines in spring. Tragedy, which re-enacted Dionysus's death and rebirth, straddled several layers of meaning: religious, civic, political.

Plato (427–347 BCE) discussed art forms like tragedy, along with sculpture, painting, pottery, and architecture, not as 'art' but as 'technē' or skilled craft. He regarded them all as instances of '*mimesis*' or imitation. Plato criticized all imitations, including tragedies, for failing to depict the eternal ideal realities ('Forms' or 'Ideas'). Instead, they offered mere imitations of things in our world, which themselves were copies of the Ideas.

Tragedy confuses the audience about values: if good characters experience tragic downfalls, this teaches us that virtue is not always rewarded. And so, in Plato's famous *Republic* Book X, he proposed to exclude tragic poetry from the ideal state.

Aristotle (384–322 BCE) defended tragedy in his *Poetics* by arguing that imitation is something natural that humans enjoy from an early age, and even learn from. He did not believe there was a separate, higher realm of Ideas, as Plato had. Aristotle felt that tragedy could educate by appealing to people's minds, feelings, and senses. If a tragedy shows how a good person confronts adversity, it elicits a cleansing or '*katharsis*' through emotions of fear and pity. The best plots represent a person like Oedipus who does an evil deed without knowing it; and the best characters are good rather than base. Aristotle's defence works well for some tragedies, especially his favourite, Sophocles' *Oedipus the King*. But the *Poetics*' fusion of moral with aesthetic criteria makes it unlikely Aristotle would approve of a character like Euripides' Medea, who knowingly kills her own children. Let us consider her story.

The tragedy *Medea* was about a foreign or 'barbarian' woman who betrayed her father and brothers to help the heroic Jason obtain the precious Golden Fleece. But after she had borne him two children, Jason took a

new, native-born bride, since his people feared Medea as a foreigner and a witch. Medea, enraged, seeks revenge by the most disturbing means possible, killing their two children. Medea also kills Jason's new bride with a poisoned robe, whose gruesome effects are described by a messenger: it melts off her skin, and even kills her poor old father who rushes to help, but becomes glued to her dissolving flesh.

Euripides engages the audience in the emotional roller coaster of these murderous events, depicting scenes Plato would surely consider unseemly. The playwright even asks us to sympathize with Medea—who is, after all, guilty of killing her own children. True, the Greeks didn't show grisly deeds on stage; but Euripides' play still conjures them up vividly, as with the poisoned robe description, or in these lines where Medea bids farewell to her children:

> Go, go . . . I cannot look at you.
> I am in agony, and lost.
> The evil that I do, I understand full well,
> But a passion drives me greater than my will.

Aristotle criticized the way Euripides ended his play, with Medea escaping in a heavenly chariot. Probably Aristotle also disapproved of Medea as a tragic heroine, because he downgraded plots like this one that show a

good person deliberately choosing evil. For Euripides to make Medea an object of sympathy or pity was *wrong*: this play does not serve the proper function of tragedy—regardless of having good poetry or a fine performance.

In ancient Athens, tragedies were selected, funded, and rewarded in certain ways, and attendance was mandated as part of the city-wide religious festival honouring Dionysus. But none of these points were mentioned in the *Poetics*. Aristotle did not explicitly discuss the civic and religious dimensions of tragedy. Because he abstracted the art of tragedy from its context, Aristotle's theory could be (and was) applied to tragedies from other eras—Shakespeare's, for example. Aristotle's idea that a tragic hero acts from a '*hamartia*' or mistake rather than evil intent was distorted into a theory of the so-called 'tragic flaw' and was applied to describe foibles of *Hamlet* (indecision) and *Othello* (jealousy). This tradition involved a misunderstanding, since Aristotle maintained that a tragic hero's character was not flawed. Rather, tragedy should show a good hero who simply made a mistake—out of human frailty—leading to disastrous results.

The classical Greek account of art as imitation was influential in other areas of art theory besides accounts of tragedy. Distinguished art historian E. H. Gombrich, for example, described the history of Western art

(mainly painting) as a search for progressively more vivid renderings of reality. Innovations aimed at more perfect semblances. New theories of perspective in the Renaissance, and oil painting with its greater tactility and richness, enabled artists to achieve an increasingly convincing 'copy' of Nature. Many people still prefer art that 'looks like' their favourite scene or object; it is hard not to marvel at virtuoso portraits by Bronzino and Constable, or at Dutch still lifes, with their juicy lemons and luscious lobsters.

But many developments (or 'contrary data') have made the imitation theory of art seem less plausible in the last century. Painting was particularly challenged by the realism of an upstart new medium, photography. Since the late nineteenth century, imitation has seemed less and less to be the goal of many genres of art: impressionism, expressionism, surrealism, abstraction. Nor does the imitation theory leave room for our modern emphasis on the value of an artist's individual sensibility and creative vision. Do Van Gogh's or O'Keeffe's irises impress us because they are accurate imitations? Plato would criticize these modern artists for creating a mere image of Beauty—hopelessly striving to emulate something ineffable or Ideal. But that did not seem to be their aim, and we value Van Gogh's or O'Keeffe's flowers for other reasons.

Chartres and medieval aesthetics

Our virtual tour now moves on to medieval France and the thriving city of Chartres in the year 1200. We will again find an art form woven into the fabric of the city's religious and civic life. Chartres was a centre of worship and part of the new Marian cult which was just starting to inject a powerful feminine element into Christianity. The cathedral, rebuilt after a fire in 1194, houses a sacred relic, a bit of fabric allegedly from Mary's tunic. The vault was completed in 1222—truly amazing progress, especially since it was hardly unique in France in that time. Chartres won the competition with its record high nave at a time when similar projects were under way in nearby Amiens, Laon, Reims, Paris, and other cities. Local lords and trade guilds made great donations of riches to ornament the cathedral, most notably, its unrivalled stained-glass windows.

The cathedral was the scene of trials and festivals, as well as worship. Within its walls people might sleep overnight, bring their dogs, hold guild meetings, and operate small booths selling their wares, like religious souvenirs and memorabilia—even wine (to avoid taxes). While social and cultural details help us understand some aspects of the cathedral's function, it also exemplifies medieval ideals of art. Gothic architecture

has a particular look: the pointed or ogival arch, ribbed vaults, rose windows, towers, and tremendous height in the nave, supported by flying buttresses. The Cathedral of Notre-Dame at Chartres is an early and fine example of Gothic style, largely the same as it was 800 years ago, with many of its original 1,800 sculptures and 182 original stained-glass windows. Chartres' architect (simply 'the master of Chartres') was clearly on top of the newer developments of medieval aesthetics. A remarkable fact is that the main entry portal has statues of pagan philosophers like Aristotle and Pythagoras, amid hundreds of saints and apostles. Why?

The study of classical Greek philosophy had a profound impact upon all forms of cultural production in Europe in the Middle Ages. Dante (1265–1321) in his *Divine Comedy* pays tribute to the classics: recall that Vergil is Dante's guide through Hell, and that Aristotle resides in the Inferno's highest circle, discoursing with other Greek writers in an afterlife spared from physical torment. At Chartres' famous school of theology, classical authors were studied as part of the 'liberal arts'. Platonic philosophy guided the aesthetic ideals of Chartres' builders; a historian of cathedrals goes so far as to write, 'Gothic art would not have come into existence without the Platonic cosmology cultivated at Chartres . . .'

Actual theorizing about beauty in this time period was particularly advanced by Thomas Aquinas (1224–1274), who was not a member of the School of Chartres. More influenced by Aristotle than by Plato, he was to philosophize in Paris at the new university there later in the thirteenth century. Aquinas was the first major Christian thinker to write about beauty (and other topics) while absorbing ideas in newly discovered and translated texts from Aristotle, introduced into Europe (particularly through Spain) only a century earlier through the mediation of Islamic culture.

Medieval philosophers, at either Chartres or Paris, did not theorize about 'art' as such, since their focus was on God. Unlike Plato and Aristotle, Aquinas did not defend an account of art as imitation. Aquinas theorized that Beauty was an essential or 'transcendental' property of God, like Goodness and Unity. Human artworks should emulate and aspire to God's marvellous properties. The medievals followed three key principles for beautiful creations like cathedrals: *proportion, light,* and *allegory.*

Guidelines about proportion were transmitted to cathedral builders from scholars in the School of Chartres, who refined theories inherited from Roman-era thinkers like St Augustine. The geometry of

a cathedral was held to add to its music-like harmony. This influence dates back to Plato's *Timaeus*, where the creative 'Demi-Urge' used geometry to plan an orderly material world. The Christian God too was seen as the master builder of the cosmos. Exacting rules were applied to the design of portals, arches, and windows, and dictated proportions of arches and galleries. Geometry ruled the design of the church itself, built in the form of a cross, with cross-arms proportional to the arms of a human figure. It is no surprise after all, then, to find Pythagoras, father of geometry, pictured in Chartres' sculptures.

Chartres' new luminosity and stained-glass windows illustrate a second principle of medieval aesthetics. In early Christian thought there is a strong dichotomy between (divine) light and (earthly) material dross. The neoplatonic Book of John construes Christ as the light of the world. Since a Gothic cathedral is the house of God, light is visible proof that the divine is present. Streaming though beautiful stained-glass images, this light conveys the glory of Heaven as the jewelled city. Aquinas also emphasized light, using the term *claritas*, which denotes internal brightness and design. For him, divinity is present in the internal forms of things on earth. A cathedral, like a good and beautiful person, should have organic unity and manifest *claritas*. Vision

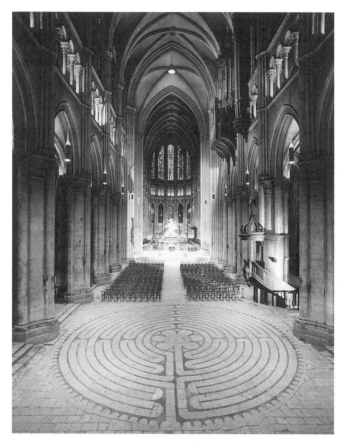

4 Everything in Chartres Cathedral, from its maze to its lofty vaulted nave and wondrous stained glass, alluded to heaven and drew believers to God's kingdom.

affords us a way of appreciating the *claritas* of something beautiful—like Chartres cathedral.

The master of Chartres enhanced luminosity to demonstrate God's heavenly illumination. Exterior walls supported by a unique two- or three-tiered sort of flying buttress promoted greater height for the vault. The master got rid of galleries (balconies) along the walls, permitting higher and brighter clerestory windows overhead. He also made possible a larger role for the rose windows. The church's remarkable stained glass and sculptures all told stories, from which Christian worshippers learned theology and Biblical narratives. This brings us to the third principle of medieval aesthetics, allegory.

Everything in a Gothic cathedral is like a book full of meaning; cathedrals have been called 'encyclopaedias of stone'. The entire cathedral is an allegory for Heaven, since it is the House of God. All aspects of the cathedral at Chartres had allegorical meaning: the rose window referred to the orderly cosmos. The square, which illustrated moral perfection, was used to design portions of the façade, towers, bases of windows, walls of the interior, and even the stones themselves.

For a medieval philosopher like Aquinas, allegory was a logical way to understand how God is present in the world. Each thing in the world could be a sign from

God. In the sculptures and windows of Chartres, the placement of figures or scenes showed how each story was related to others. Pythagoras and Aristotle appeared in the portal columns underneath statues devoted to Mary, showing that the Liberal Arts (and their respective fields of geometry and rhetorical persuasion) must support and be mastered by theology. Similarly, a stained-glass window showing the story of the Good Samaritan was related both to an Old Testament story told below it and to a depiction of Jesus above, with a strict order of reading from bottom to top and from left to right. The size, layout, and relationships among all the sculptural groupings and doorways, as among all the windows and their parts, were dictated by the same rules of proportion that governed other aspects of the cathedral.

Chartres manifested an array of artistic expertise ranging from architectural design to the highly skilled labour of masons, woodcarvers, stonecutters, window painters, and others. Individuals of great ability worked here, perhaps receiving high pay and recognition, but ultimately subordinating their efforts to the spiritual purpose of the whole. The result of collaboration at Chartres is an overall harmony serving the three primary Gothic aesthetic principles of proportion, light, and allegory.

Versailles and Kant

A modern-day tourist to France can make short train trips from Paris to visit medieval Chartres on one day and Versailles the next. Having done this tour, I would be hard-pressed to say which place had greater impact. Chartres is fascinating. You catch picturesque glimpses of the cathedral's mismatched towers from the city's narrow medieval streets. By comparison, Versailles dazzles by sheer scale and spectacle. The palace is extraordinary, as is its setting amid parks, fountains, waterways, and gardens. It is these gardens I wish to focus on next.

In the seventeenth and eighteenth centuries, gardens were recognized as high artistic achievements. In 1770 Horace Walpole listed gardening along with poetry and painting as the 'three sisters or graces'. Designers or 'gardenists' like Capability Brown in England earned fame and fortune. André Le Nôtre was from a family of gardeners called upon by Louis XIV to design a garden grand enough to fit his image as 'The Sun King'. Le Nôtre spent 50 years of his life (beginning in the 1660s) upon the magnificent gardens of Versailles.

Designed around the theme of Apollo the sun god (to honour Louis), Versailles' gardens drew upon Greek mythology: its fountains and statues depicted

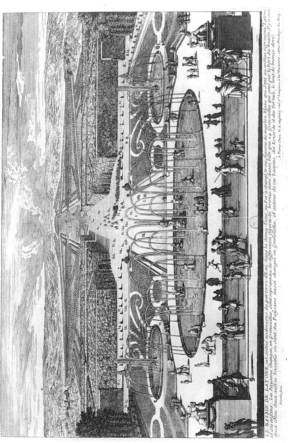

LE BASSIN DE LATONE, et cette antique du parterre d'Eau, dans la demi-lune, ou l'on a dressé, pour figure de marbre blanc, qui sont au milieu représente, Latone d'un original La Fontaine tranquille, en grenouilles, s'est représentés à différentes figures de bronze doré, dont une, sous la figure de la Fontaine d'y a eu deux Nids, deux milieu bronze doré ce sont les Paysans, aucle, changés, en Grenouilles, et autour de ces bassins, des Lezards et des Tortues, le tout de bronze doré.

Perelle fecit A Paris Chez, N. Langlois, rue S. Jacques à la Victoire, Avec Privilege du Roy

5 This early engraving by Perelle shows the sort of image Kant might have seen of Versailles, emphasizing the play of waters in the Latona Fountain and the view along the Allée Royale.

Apollo's mother Latona, his sister Diana, etc. The scale was enormous, both in years expended and in hard labour spent transforming the landscape, which started out as a swampy hunting lodge. The Versailles official Web site says that the garden covers 2,000 acres, with 200,000 trees, 210,000 flowers, 50 fountains, 620 fountain nozzles, and 3,600 cubic metres per hour consumed during the annual 'Full Play of the Fountains'. Water was as much a part of the original design as trees and plants; fountains and waterways had their own designs, with adjustable nozzles to create splashing sculptural effects. Sometimes gondoliers and sailors in costume were hired to ply the waters of the Grand Canal while musicians played on shore.

The classical allusions everywhere at work in Versailles would require an educated audience to appreciate them. Like the chateau, the garden served a social, political, and cultural function during the period of absolute monarchy. The garden signified the king's dominance; its vistas hinted that the king's ownership extended as far as the eye could see (and even beyond). But there is also an aesthetic sensibility at work in the garden's complex geometrically ordered plan, which included broad alleys, low gardens or *parterres* with embroidery designs, the huge mile-long Grand Canal, and small enclosed wooded alcoves or *bosquets*, each

with its own theme, enhanced by fountains. (In our next chapter, we will see how different in style a Zen Buddhist garden is—emphasizing harmony with, rather than ownership of, nature.)

Gardens did not count as the highest form of art for Kant, but he took them seriously. Kant's great work in aesthetics, his *Critique of Judgment* was published a century after Le Nôtre began his work. Kant never visited Versailles, though he probably saw engravings of it and knew of gardens emulating it, like Herrenhausen in Hanover (scene of some of the philosopher Leibniz's conversations). Remember that Kant emphasized formal features and the idea of 'purposiveness without a purpose'. Versailles, as a garden aiming at Beauty, did not serve the lowly purpose of growing fruits and vegetables. Kant saw the gardener as someone who 'paints with forms', and he listed gardens in his classification of the fine arts:

> *[L]andscape gardening* . . . consists in no more than decking out the ground with the same manifold variety (grasses, flowers, shrubs, and trees, and even water, hills, and dales) as that with which nature presents it to our view, only arranged differently and in obedience to certain ideas.

Kant admits that, 'it seems strange that landscape

gardening may be regarded as a kind of painting', but then explains that this art can meet his criteria for 'free play of imagination'.

Kant did not examine the garden as a signifier of social status, educational privilege, or our human relationship to God and nature. He emphasized instead that excellent form produces a *harmony of the faculties*, which prompts us to label the garden *beautiful*. Kant might have praised Versailles as orderly without being too regular and predictable. Entering into a grove or *bosquet*, one is surprised by each new arrangement and by the different but 'right' juxtapositions of plants, statues, vases, and fountains. Kant criticized the more 'natural' flowing English gardens since they 'push the freedom of imagination to the verge of what is grotesque'. The constant changing variety within the landscape of Versailles, its seeming order that has no particular aim, and especially the play of sensations aroused by its varying fountains, would make it beautiful—something that stimulates 'free play of imagination'.

Kant spoke often of the beauties of nature and praised the 'free beauty' of a flower or hummingbird. His book revised traditional treatments of beauty by adding in an account of the sublime: bold rocks, thunderclouds, volcanoes, and high waterfalls, or artworks with

vast scale, like the Pyramids of Egypt and St Peter's Basilica in Rome (again, both places Kant had never visited). Kant's treatment of the sublime paved the way for new genres of landscape painting and for Romantic poets like Wordsworth, Byron, and Shelley, for whom Nature would serve as both inspiration and elemental backdrop—not orderly, tame, and playful, as shown by Le Nôtre at Versailles.

Parsifal: *suffering and redemption*

The next two artists I will discuss, Richard Wagner (1813–1883) and Andy Warhol (1928–1987), exemplify the modern cult of artistic personality. Wagner played the part of Romantic genius to a 'T' with his tumultuous love life, fanatical admirers, flights from scandal and debt, and international fame. Fortune found him in the patronage of King Ludwig II of Bavaria, who built him a home and theatre at Bayreuth, still a pilgrimage point for Wagnerians today (with a ticket waiting list of seven years). I will look at an illustrative work by each artist: Wagner's last (and, some say, greatest) opera, *Parsifal*, and Warhol's early signature piece, his *Brillo Box* from 1964.

Wagner's musical genius is undisputed. Commenta-

tors marvel at his manipulation of hundreds of musical themes in prodigiously ambitious operas. He introduced a new dramatic role for orchestration with scores that are richly textured, subtle, and profound. His music poses hideous challenges to singers and requires enormous stamina and power. Wagner saw opera as 'Gesamtkunstwerk', a complete art form in which he controlled not only musical features but also the libretto, staging, costumes, and sets. His multi-opera 18-hour *Der Ring des Nibelungen* cycle develops an elaborate mythological plot encompassing Rhine maidens, gods, dwarfs, Valkyries, dragons, flying horses, rainbow bridges, etc. Wagner's influence has reverberated into associated art forms, like motion picture scoring. His use of *leitmotifs*—phrases associated with particular themes or characters, as well as used for dramatic effect—recurs, for example, in John Williams's music for the *Star Wars* movies.

Wagner's opera *Parisfal* is a tale in which suffering is celebrated, as we follow the path of a young knight who is a 'pure fool made wise through pity'. Critics either love or hate the opera, calling it sublime or decadent. The five-hour-long opera tells a grand story about seduction and loss of innocence in the search to reunite the Holy Spear with the Holy Grail. It spans musical emotions from the jagged shrieking solos of the

6 King Amfortas with the young Parsifal beside the Holy Grail, in this scene from Robert Wilson's controversial staging of Wagner's *Parsifal* at Houston Grand Opera.

sorceress Kundry to the seductive siren songs of the Flower Maidens. The music becomes radiant, signifying spiritual transformation, in the final act, set on Good Friday. Parsifal, now Knight of the Grail, heals the king's wound by touching it with the Holy Spear. The final words are 'redemption for the redeemer'.

Philosopher Friedrich Nietzsche (1844–1900), one of *Parsifal*'s fiercest critics, was a former fan who had been in the audience at the premiere of Wagner's magisterial *Ring* in 1876 (along with composers Liszt, Tchaikovsky, and a throng of monarchs and aristocrats). Nietzsche met Wagner in 1868, and the two became friends. Nietzsche's book *The Birth of Tragedy* (1872) was dedicated to Wagner and spoke in glowing terms of a rebirth of tragedy that everyone knew referred to the composer. Nietzsche, a philologist and young professor, described the origins of tragedy from the worship of the god Dionysus. Tragic vision showed the very essence of life as violence and suffering, with no meaning or justification. The beauty of 'Apollonian' poetry in tragedy provides a veil through which we tolerate the horrific yet enticing Dionysian vision, which was conveyed especially through music and harmony. In Wagner's operas, as in Greek tragedy, suffering was revealed and even revelled in, as Wagner's wonderful and often dissonant music recaptured the Dionysian

life-force. Nietzsche, who lamented the weakening of Germany's 'pure and powerful core' by 'foreign elements', celebrated Wagner for revitalizing German/European culture by evoking primitive roots of ancient Nordic and Teutonic mythology—using Aryan rather than Semitic myths.

But in 1888 Nietzsche published *The Case of Wagner*, berating the composer and *Parsifal*. Why this turnabout? Nietzsche found *Parisfal*'s music wonderful: he praised its clarity, 'psychological knowingness', and 'precision', and even called it 'sublime'. However, Nietzsche rejected *Parsifal*'s message as too 'Christian', with its theme of a sacrificial saviour and redemption: 'Wagner . . . sank down, helpless and broken, before the Christian cross', 'decaying and despairing and decadent'. Nietzsche found the plot life-denying and 'sick', not full of affirmation—not truly Dionysian. Well-educated musically, Nietzsche felt that *Parsifal*'s sheer beauty only made things worse, by tempting one to succumb to the composer's intentions. When he lampoons the mass adulation of Wagner at Bayreuth, Nietzsche sounds like Plato warning about the seductive powers of tragedy.

Some modern commentaries feel a similar ambivalence about Wagner: while they may appreciate the beauty and complexity of his music, they find aspects of

Wagner's 'Aryan' mythologizing repugnant. Wagner's rabid anti-Semitic writings were read by an admiring Hitler, and his operas became virtual state music for the Nazis. This has led to his music being unofficially banned in Israel until quite recently. Even without this worry, some people ridicule Wagner for grandiose themes and plots, or for his self-absorbed characters like Tristan and Isolde, with their unwieldy 40-minute love duet. We need not share Nietzsche's critical view to dismiss the plot of *Parsifal* as pretentious mumbo-jumbo, regardless of religion and politics. For many people, and not just Nietzsche, then, aesthetic and moral concerns clash to create a quandary in assessing Wagner's operas.

Brillo Box *and philosophical art*

Andy Warhol, with his well-crafted image—the platinum hair, whispery voice, dark eyes—was expert at self-promotion. Obsessed with celebrities, Warhol loved jet-setting and partying. Yet he said, 'I think it would be terrific if everyone was alike', and coined the cynical slogan that 'everyone has their fifteen minutes of fame'. Warhol emerged in the 'Pop Art' movement of the 1960s, a movement tied into fashion, popular culture,

and politics. He brought attention to everyday visual products in the environment around us and claimed he wanted to 'paint like a machine'. Phenomenally successful, he left an estate valued at over $100 million.

Lest Warhol seem lightweight, we should recall his sobering disaster images: Civil Rights riots with attack dogs, the electric chair, and grisly auto accidents, all transformed (like his Marilyn Monroes) into brightly coloured silk-screened panels. Warhol is hard to pin down. His *Last Supper* series done in Italy (based on Leonardo's 'real' one) was meant seriously by the artist who had remained a devout Christian.

Warhol helped spark the transition from macho New York Abstract Expressionism to playful gender-bending postmodernism. Warhol was already successful as a commercial artist when he exhibited stacks of hand-stencilled plywood boxes at the Stabler gallery in New York in 1964. The boxes had a tremendous impact on philosopher Arthur Danto, who has repeatedly discussed them (he even wrote a book titled *Beyond the Brillo Box*). Warhol's *Brillo Boxes* looked just like one in a supermarket, and Danto found this puzzling:

> Why was it a work of art when the objects which resemble it exactly, at least under perceptual criteria, are mere things, or, at best, mere artifacts? But even if artifacts, the parallels between them and what Warhol

made were exact. Plato could not discriminate between them as he could between pictures of beds and beds. In fact, the Warhol boxes were pretty good pieces of carpentry.

Danto wrote a much-discussed paper, 'The Art World', about this puzzle. His essay, in turn, prompted philosopher George Dickie to formulate the 'institutional theory of art', according to which art is 'any artifact . . . which has had conferred upon it the status of candidate for appreciation by some person or persons acting on behalf of a certain social institution (the art world)'. This meant that an object like *Brillo Boxes* was baptized as 'art' if accepted by museum and gallery directors and purchased by art collectors.

But, Danto objected, the *Brillo Boxes* were *not* immediately accepted by the 'artworld': the director of the National Gallery of Canada declared they were not art, siding with Customs inspectors when a dispute arose about shipping them; hardly anyone bought them. Danto argued instead that the artworld provides a background theory that an artist invokes when exhibiting something as art. This relevant 'theory' is not a thought in the artist's head, but something the social and cultural context enables both artist and audience to grasp. Warhol's gesture could not have been made as art in ancient Greece, medieval Chartres, or

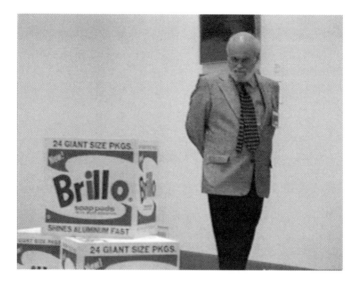

7 Philosopher Arthur Danto pondering why Andy Warhol's stacked *Brillo Boxes* are art.

nineteenth-century Germany. With *Brillo Boxes*, Warhol demonstrated that anything can be a work of art, given the right situation and theory. So Danto concludes that a work of art is an object that embodies a meaning: 'Nothing is an artwork without an interpretation that constitutes it as such'.

Danto has criticized earlier views of art (like those we have surveyed in this chapter):

> [M]ost philosophies of art have been by and large disguised endorsements of the kind of art the philosophers approved of, or disguised criticisms of art the philosopher disapproved, or at any rate theories defined against the historically familiar art of the philosopher's own time. In a way, the philosophy of art has really only been art criticism.

Danto himself tries to avoid endorsing any particular type of art. His pluralist theory helps explain why the artworld now accepts such diverse entries as bloodfests, dead sharks, and plastic surgery as art. He sees his job as describing or explaining why people have held different things to be art in different eras: they 'theorize' about art differently. In our time, at least since some of Duchamp's work and Andy Warhol's *Brillo Boxes*, almost anything goes. This makes the narrow and restricted views of earlier philosophers, who defined art

in terms of Beauty, Form, etc., seem too rigid. Even shocking art like Serrano's *Piss Christ* can now count as art: an object with the right sort of idea or interpretation behind it. Serrano and his audience share some background theory or context within which the photo may be viewed as art: it communicates thoughts or feelings through a physical medium.

Danto argues that in each time and context, the artist creates something as art by relying on a shared theory of art that the audience can grasp, given its historical and institutional context. Art doesn't have to be a play, a painting, garden, temple, cathedral, or opera. It doesn't have to be beautiful or moral. It doesn't have to manifest personal genius or devotion to a god through luminosity, geometry, and allegory.

Danto's open-door theory of art says 'Come in' to all works and messages, but it does not seem to explain very well *how* an artwork communicates its message. As the art critic for *The Nation*, he must suppose that some works communicate better than others. (Saying that something is art is not at all the same as saying that it is *good* art.) Writing as critic, rather than as philosopher, Danto sometimes praises and sometimes finds fault. He explains that, 'The task of criticism is to identify the meanings and explain the mode of their embodiment'. This requires considering both material and formal

features of artworks: the poetic diction of Euripides, the play of waters in Le Nôtre's fountains, the height and light of Chartres cathedral, Wagner's chord progressions and instrumentation—Danto even noted that Warhol's plywood Brillo boxes were well-made. Many details are relevant to how artists embody their ideas in art. I want to look further into issues of meaning and value. But first let's do more touring, this time around the globe, to consider examples of non-Western art.

3

Cultural crossings

Gardens and rocks

Art has taken varied forms in distinct historical contexts. We recognize and respect many art forms of the past, like tragedy—although our context for experiencing them may be different. But some arts of the past seem very alien. The complex symbolic gardens of seventeenth- and eighteenth-century France have few parallels in the West today. Stained glass, so essential to Chartres' splendour, is now more associated with craft than art; and landscape gardening seems a hobby or design practice rather than 'Art'. Perhaps we should examine our assumptions about the differences between craft and art, as about the relation of art to the natural landscape.

For Japanese readers, the garden is probably a living art form. Versailles symbolized the power of the king, but a Zen garden symbolizes a person's relation to

nature and higher reality. Japanese gardens look 'natural' to Westerners, with their trees, rocks, winding paths, ponds, and waterfalls; but all is purposeful. The Zen tea ceremony is guided by subtle values of harmony and tranquillity that affect everything from the choice of flowers, window-shades, and pottery, to the way the tea is prepared and served. Japanese art reflects Shinto-ism as well in art forms such as *bonsai* trees, *ikebana* flower arrangements, and self-regulating moss gardens, like Kokiden in Kyoto.

The rocks and raked stones of some Zen gardens can puzzle Westerners. Large craggy boulders were also prized in China and moved—often at great expense—into ancient gardens (or even into modern skyscrapers in Shanghai!) for their symbolic associations. Chinese gardens typically included a building for scholarly con-templation and meditation. The Emperor's pleasure palace Yuan Ming Yuan featured bridges and gazebos within a vast artificial but natural-looking landscape. Reports from the 'Far East' had a major impact when they began to be published in Europe in 1749; by com-parison, Versailles must have seemed dreadfully stiff and formal. The more free-flowing English gardens showed the impact of reports from China.

Culture travels, like people. There are Chinese and Zen gardens in cities from Sydney to Edinburgh to San

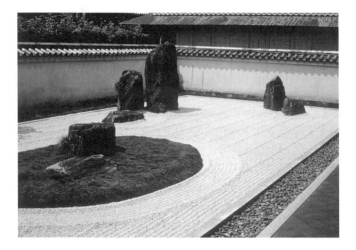

8 A Zen Buddhist garden in Japan; the raked stones and carefully placed craggy boulders invite contemplation.

Francisco. 'World Music' is enormously popular: the latest disco style breezily combines flamenco with jazz and Gaelic traditions. Dance troupes from Africa and South America routinely perform overseas. It would be impossible to disentangle strands of influence in the spaghetti western, samurai film, Hollywood action flick, Indian adventure story, and Hong Kong cinema. In the modern world, no culture, however 'primitive' and remote, remains isolated. The Huichol Indians, who live in mountain villages of Mexico, make their masks and *rukuri* votive bowls for peyote rituals using glass beads imported from Japan and Czechoslovakia.

Can art break down barriers among cultures? John Dewey thought so; he wrote in his 1934 book *Art as Experience* that art is the best possible window into another culture. Insisting that 'art is a universal language', Dewey urged us to strive to achieve the internal experience of another culture. He thought this required an immediate encounter, and not studying 'external facts' about geography, religion, and history: 'Barriers are dissolved, limiting prejudices melt away, when we enter into the spirit of Negro or Polynesian art. This insensible melting is far more efficacious than the change effected by reasoning, because it enters directly into attitude'.

Dewey's belief that 'the esthetic quality is the same

for Greeks, Chinese, and Americans' suggests that he is mystifying our experience of art as direct, wordless appreciation. This smacks of modernist searches for a universal formal quality of 'Beauty'. Indeed, Clive Bell, the art critic, emphasized the value of Significant Form, rather than any particular content, in 'primitive' art. But to equate Dewey's approach with Bell's would be unfair, since Dewey knew that 'the language of art has to be acquired'. He did not define art as Beauty or Form, but said instead that it is 'the expression of the life of the community'. I like this definition, though I would go further than Dewey in saying we must know 'external' facts before trying to acquire the 'internal' attitude of appreciation for another community's art.

For example, my direct experience of African *nkisi nkondi* fetish statues from Loango, in the Kongo region, which are bristling with nails, is that they look quite fierce—like the horror-movie monster Pinhead from the *Hellraiser* series. This initial perception is modified when I learn 'external facts': that the nails were driven in over time by people to register agreements or seal dispute resolutions. The participants were asking for support for their agreement (with an expectation of punishment if it is violated). Such fetish sculptures were considered so powerful they were sometimes kept outside of the village. Although I may directly perceive that

9 Each of these three *nkisi nkondi* nail fetish sculptures in the Menil Collection served as a powerful guarantor of justice for its village or region.

the sculptures embody frightening power, I do not comprehend their social meaning without understanding additional facts about why and how they were made. Original users would find it very odd for a small group of them to be exhibited together in the African Art section of a museum.

It is hard to disagree with Dewey's aim of encouraging people to have a genuine emotional encounter with art from another era or culture. I do not mean to say we cannot begin to appreciate the power of nail fetish sculptures without further facts; but information adds considerably to our experience. Knowledge of context helps enhance our experience of other art forms too—say, coming to appreciate the religious associations behind reggae, gospel music, or a Bach mass. In this chapter I will take up further issues about how cultural contexts and interactions affect our understanding of many diverse cultural manifestations of art.

In search of the 'primitive', 'exotic', and 'authentic'

It is often hard to understand what is valued in the art of another culture, and why. African masks and carvings, like Zuni Indian fetishes and Hindu classical dances,

are components of religious ceremonies. To me, Islamic calligraphy on a mausoleum or mosque looks like a beautiful decoration, but it has meaning I miss out on because it reprises verses from the Holy Koran in Arabic, which I cannot read. Or, a Chinese master's dextrous rendering of bamboo with 'bamboo in his heart' may elude me as I search his simple-looking watercolour for some further form or meaning.

Cultures often come into contact through means that limit communication, such as imitation, shopping, and mass-market sales. Tourism affects even the most sincere admirers who seek understanding of alien cultures. When Westerners collect non-Western art or view it in a museum, we probably miss much of its original context. And ignoring the context can lead to cultural appropriation—collecting work from 'exotic' cultures like trophies. Recently I received a gift catalogue in the mail that offers Ashanti masks, Moroccan drum furniture, Bhutanese vests, Punjabi purses, Balinese clothes hooks, cabinets topped with Buddha sculptures, and Feng Shui soaps. It also sells bonsai plants.

Sometimes 'primitive' or 'exotic' art is not far away across oceans, but within our own nation. During the Aesthetics Society meetings in Santa Fe, there was a colourful exhibition of Indian Pueblo dancing. As dancers performed the Buffalo, Eagle, and Butterfly Dances,

Tewa elder Andy Garcia explained their religious significance in his Native American culture. Even though we could learn from Mr Garcia's previews, these 'native' dances were still quite 'foreign'. His chanting seemed eerie and repetitive, and the dancers looked expressionless, with stiff upper bodies and stylized arm movements. I was distracted by their beautiful costumes: soft animal skin boots, striking headpieces with eagle and parrot feathers, elaborate silver concho belts, turquoise squash blossom jewellery, and tinkling ankle bells.

Much indigenous art emerges from a complex history reflecting many interactions during colonial rule. In one of the more extraordinary examples, women in northern Canada learned how to make the prints that are now so definitive of Inuit art from visiting artist James Houston, who was hired by the government to promote native crafts as a form of self-subsistence. He introduced Japanese print-making techniques, enabling the women to adapt skills from their traditional embroidered vests and boots to produce more marketable prints. 'Authentic' Native Americans are sought out in the New Age trendiness of people who find models of cosmic harmony in Aboriginal Americans, whether in Cape Dorset, Canada; Zuni, Arizona; or Chichèn Itzá, Mexico. Santa Fe's numerous galleries present beautiful (and expensive) Indian

10 Kenojuak Ashevak's print, *Enchanted Owl*, reflects both Inuit design traditions and the introduction of Japanese print-making techniques into northern Canada.

pueblo pottery and kachina dolls, but there are also countless shlocky paintings of exotic Indian maidens who gaze across the mesas at sunset. Some pueblos are thronged with tourists at special ceremonies, but others remain closed to the public or prohibit filming and photography so as to forestall commercialism and disrespect.

Cultures in conjunction

Despite gaps between cultures, intercultural contact is age-old. The art of ancient Greece was influenced by Egyptian sphinxes, Scythian goldsmithing, Syrian love goddesses, and Phoenician coin design. Even the 'Japanese' aesthetic of Zen Buddhism reflects a centuries-long historical interaction between Japanese culture and the new, alien religion of Buddhism, which travelled to Japan from India by way of China and Korea. The contact among cultures within Islamic civilization reminds us that ethnic pluralism and multiculturalism are not brand new in our century. The Chinese exported ceramics for the popular taste of early Muslim rulers in the ninth century. Cordoba in thirteenth-century Spain was a multinational trade centre; pottery made in Spain by Muslim artists

featured crosses for export to Christian buyers in the north, just as textiles and carpets with heraldic designs were made in Persia for export to the chateaux of Europe. The ramifications of these cultural interactions are complex. Perhaps the best-known 'Turkish-looking' form of art, the Iznik tile, reflects the Ottoman rulers' great interest in Chinese porcelains: these tiles borrowed their designs of peonies, roses, dragons, and phoenixes from Chinese art (see Plate II).

It can be difficult to demarcate clearly between good and bad cultural connections. Asian art has had profound influences on the West across the centuries. Some of these appropriations are symptoms of a long-standing European tendency to exoticize the East, but others reflect serious cross-fertilization. Chinese porcelain was imitated not only by Persian ceramicists, but also by Italian majolica makers, Delftware producers, and English bone china designers. Japanese watercolours shown at Far East exhibitions in Paris in the late nineteenth century affected the compositions and palettes of Matisse, Whistler, and Degas. 'Oriental' musical modes influenced composers like Mozart, Debussy, and Ravel. Puccini's Chinese princess Turandot is a fanciful creation based on a version of an Arabian Nights tale from Persia—yet Puccini did include seven 'authentic' Chinese tunes in the opera, based on material recently

published in Europe. Olivier Messiaen's idiosyncratic instrumentation and harmonies were grounded in extensive research into South Asian musical modes. And theatrical producer Robert Wilson's controversial stagings of Wagner's operas, like his *Parsifal*, combine the technical wizardry of lasers and light shows with the sombre pacing, poses, and simplicity of Japanese *Noh* drama.

'Primitive' art in pristine spaces

Despite our best efforts to understand the art of another culture, colonial attitudes may creep in. Near Cairns in northern Australia, in Kuranda, there are small art fairs with booths where many Aboriginal artists sell their wares: didjeridus, paintings, animal carvings, and decorated boomerangs. I bought a small painting of a barramundi fish from an ultra-'Authentic' looking Aboriginal man, Mr Boonga, who was tall, dark, and jovial, with a big cloud of white hair. He explained that in his tribe only someone from a certain clan could catch and cook the (delicious) barramundi fish; in some groups, only certain people owned rights to paint it. My 'primitive' contact then surprised me when he whipped out photographs and news clippings of his

trips and exhibitions in France and Belgium! I had a similar jolt when I watched the Aboriginal theatre group perform at Kuranda's cultural centre. They (like the Tewa Pueblo dancers) wore traditional clothing; they enacted their story to eerie-sounding didjeridu music, miming the ancient murder and rebirth of a hero. Then the lead actor stepped out of character at the end, still clad in loin-cloth and body paint. He grinned and said 'G'day!', and encouraged the audience to buy CDs of their music in the gift shop. It was only my own narrow expectations, of course, that made this seem startling—as though he but not I had to remain trapped in the amber of the past.

Cultural borrowing was the focus of two major museum exhibitions, one in 1984, the other in 1989, that illustrate how controversial it is to consider and present such contact when Westerners attempt to broaden the category of 'art'.

An exhibit at the Museum of Modern Art (MoMA), *'Primitivism' and Modern Art* in 1984 took the word 'primitive' with a grain of salt, as indicated by the scare quotes around it in the title. And yet critics wrote that the exhibit did a disservice to the non-European art it presented. To celebrate the 'Primitive' art, exhibitors showed how it influenced modern European artists like Picasso, Modigliani, Brancusi, Giacometti, and others.

The show decontextualized the 'Primitive' art by not mentioning information about artists, eras, cultures, or original uses—all that mattered was the look or form. Critic Thomas McEvilley wrote:

> "Primitivism" lays bare the way our cultural institutions relate to foreign cultures, revealing it as an ethnocentric subjectivity inflated to coopt such cultures and their objects into itself. . . . this exhibition shows Western egotism still as unbridled as in the centuries of colonialism and souvenirism.

In contrast, the 1989 exhibit, *Les Magiciens de la Terre*, organized by the Pompidou Centre for Modern Art, sought to treat all the artists in it with equal respect. The same sort of context was included about each artist. But again, complaints were registered. Critics felt that the displays went too far in equating disparate pieces: for example, hanging the earthworks installation piece, *Red Earth Circle*, by Richard Long, above an earth painting by a collective of Yuendumu Aborigine artists. The non-Western art was still not sufficiently contextualized for Western viewers. It is hard to deny that there is a hint of New Age mysticism in the show's title, which smacks of the desire for 'authentic' spirituality and shamanistic authority, to escape participation in a crass and demeaning art market system.

11 One installation at the *Les Magiciens de la Terre* exhibition, Paris 1989, placed Richard Long's mud circle on the wall above a ground painting done by the Yuendumu Aboriginal community from Australia.

More recent museum exhibitions have often pro-
vided far more context. (Sometimes this reaches
amusingly paradoxical proportions—as when the San
Francisco Museum of Modern Art guide to African Art
for teachers and students solemnly announces that the
museum is showing objects that do not belong in a
museum.) Audiophones direct the visitor's steps and
stops, and museums offer increasingly lengthy wall
texts, catalogue essays, preview lectures, and docent
tours. Then, inevitably, follows the gift shop with its
toys, dolls, postcards, posters, musical tapes, calendars,
earrings, and even wastebaskets. It is difficult to say that
an artistic wastebasket is a symbol of cultural
understanding!

Turning to anthropology

High Islamic art includes not just calligraphy but also
coins and carpets. Swords in Japan have long been
highly prized and designed, like tea vessels, following
Zen aesthetic principles. Aboriginal boomerangs,
Eskimo kayaks, Yoruba *ibeji* or 'twin' dolls, are just a few
other examples of artwork that may typically be classi-
fied as 'crafts'. We could say much the same, of course,
of much Western art we now see in museums: Greek

pots, medieval chests, Italian majolica, French tapestries. Even Michelangelo's and Donatello's sculptures were commissioned to adorn public spaces, churches, or tombs. Many tourists who visit Chartres cathedral have little knowledge of or respect for the medieval belief system that gave it aesthetic unity. If a Zen garden is art, it is probably not so for the reasons that Kant would have said that Versailles was art; and you will not necessarily be paying the Zen monks a compliment by calling their garden 'art' in your sense. You may instead show chauvinism and ignorance.

Do various cultures around the globe share a concept of 'art'? In his book *Calliope's Sisters*, a study of art across 11 world cultures, Richard Anderson (an anthropologist specializing in art, or 'ethno-aesthetician') argues that we *can* find something akin to art in all cultures: certain things are appreciated for their beauty, sensuous form, and skill of creation, and are treasured even in non-utilitarian settings. Anderson's study is not confined to contemporary cultures; the Aztecs, for example, admired and collected the art of their predecessors, the Toltecs and Olmecs. Anderson proposes to define art as 'culturally significant meaning, skilfully encoded in an affecting, sensuous medium'. I would endorse this definition and so, I suspect, would John Dewey—it sounds like a more specific version

of Dewey's idea that art 'expresses the life of a community'.

It is not always easy to discern, however, what counts as this 'culturally significant meaning'—even after careful and respectful study. Another anthropologist, James Clifford, has juxtaposed the displays of totemic objects in the British Columbia Museum of Modern Art (as modernist abstract-shape sculptures) with their exhibition in Northwest Coast Indian galleries. After significant religious items were returned to tribal peoples, there were disagreements about how to display them. One group decided they should not be displayed at all. Another showed them as individual objects with commentary, whereas still another exhibited them only in a ceremonial context that recreated the potlach ceremony in which they would traditionally be employed.

Anthropologists at times have even influenced the art production of the cultures they study. The American Eric Michaels was observing Australian Aboriginal groups in the late 1970s, when the international art market 'found' Aboriginal art. Aboriginal dot paintings resemble Western Op art or abstract expressionism, but the artists' real aim is to create a 'shimmering' effect so as to evoke and make contact with the archetypal Dream Time. Michaels says Aboriginal artists have very

different notions of creativity and of ownership than many European artists, but,

> . . . as the painters interacted more and more with Australian and then overseas markets, attracting sophisticated brokers, critics, and patrons along the way, the 'Papunya Style' began to interact with certain issues in 1960s and 1970s international painting, especially the extreme schematizations of New York minimalism.

Encouraged by this sudden demand for their work, the artists undertook some large-scale projects. Michaels sought to avoid intervention, but he grew concerned when a collective working on one huge project, *Milky Way Dreaming*, began to be affected by efforts of one artist who had travelled afield and begun to use the dot style of the Papunya group. Worried about the possible financial impact of such a 'mixed' style, since an excess of dots confused the story of the painting in its large central figures, Michaels commented to an elder that 'Europeans might get confused looking at the picture'. After discussion, the men evened out the anomalous section.

Anthropologist Susana Eger Valadez also intervened in a tribal culture's art production. When she went to study the Huichol Indians in western Mexico in 1974, she was appalled to find their traditional arts being

12 Juventino Cósio Carrillo, a Huichol Indian artist from Mexico, works with his family as a team to create traditional beaded masks.

disrupted by the incorporation of new symbols: instead of hummingbirds and corn, there were now Mickey Mouses and VWs appearing in the women's elaborate embroidery. She persuaded them to stick to traditional imagery. Even so, the Huichol, who are very poor, have modified their art to satisfy an increasing market. Their contact with Oaxacan wood-carvers is facilitated by regional cultural arts centres, leading to new forms of production beyond their traditional beaded votive bowls. The Oaxacans sell their carved jaguar heads and other animals to the Huichol to be beaded, with both groups benefiting. The Huichol's traditional form of art reflects another significant outside influence, from a Dallas collector who thought that rounder beads might facilitate greater perfection of design; in 1984 he had beads shipped in from Japan and Czechoslovakia. The Huichol loved the new beads and immediately adapted to their use for decorating bowls and carved objects (see Plate II).

Some Native Americans now face hard decisions about their role and opportunities as artists. Young people educated at art schools who are as familiar as any other modern-day students about recent global art movements may feel both obligations and tensions about pursuing traditional art styles, subjects, and materials. It is burdensome if the twenty-first century

'primitive' artist is supposed to have escaped the march of history to help the rest of us treasure some mythical past.

Indigenous peoples in the Americas and Australia are not culturally isolated and homogenous. So also are there diverse people in major urban centres in the First World, reflecting many cultural influences and ethnic conjunctions. Next I want to comment on two important issues arising from such new cultural connections.

Postcolonial politics and diasporic hybrids

We have read above about how postcolonial attitudes can turn up in museum exhibits, tourist markets, and in trade affecting local production. Twentieth-century artistic practices reflected the emergence of many nations around the world into independence from colonial rule. This has never been a smooth process, and has sometimes involved years of bloody revolution. Dictators and other political powers often suppress art because it provides a point of critical resistance, building a new national identity by evoking cultural roots.

The twentieth century saw many examples of arts

playing a powerful political role, sometimes eliciting harsh reprisals and censorship, even death (or death threats). Many prominent authors have created work while in prison or exile. The *fatwah* or death sentence against Salman Rushdie prompted by his book *The Satanic Verses* is the best-known case; it illustrates complex issues of the postcolonial era. Rushdie, an Indian expatriate living in London, writes in the language of the colonial rulers, English. His huge, rich (and difficult) book combines allusions to Islam and to Hindu theology with contemporary social critique (of India and Britain alike), interspersed with magical realist scenes: people fall to earth from an airplane explosion without being harmed, suddenly sprout horns and tails, time-travel, or undertake a pilgrimage guided by butterflies.

Certain episodes that present a satirical version of the Prophet Muhammad and his wives shocked and infuriated some Muslims, much in the way Serrano's *Piss Christ* offended many Christians. The *fatwah* against Rushdie (now lifted) is deplorable, but it should not be understood as just a harsher equivalent of the censorship of free speech in the West. The threat extended beyond national boundaries and constitutions, reflecting the unique nature and scope of Islamic law (as interpreted by certain mullahs). We see here a sharp

clash between Rushdie's sophisticated postcolonial and postmodern style of literature and the phenomenon of Islamic fundamentalism, which hearkens back to earlier periods of empire that seem incompatible with contemporary nationhood. This phenomenon is linked to complex issues: secular divisions within Islam, geopolitics of the international oil economy, and shifting international alliances during the collapse of the Soviet Union.

This leads to my second point, concerning disaporic hybrids. 'Diaspora' is a term most famously used to describe the situation of the Jews since their dispersal after the destruction of Solomon's Temple in Jerusalem in the sixth century BCE. The 300-year period of African slavery has resulted in another great diaspora, as have other sorts of colonial rule and practices. There is a new impact of diasporas on the production of art, partly because of global telecommunications. What holds a community together in periods of loss of their homeland is often their cultural traditions, including religions and rituals along with dance, singing, storytelling, painting, and so on.

As people are forced (or choose) to move around the globe, their descendants emerge with a new, hybridized identity. Many immigrants preserve their cultural traditions for multiple generations, with art playing a key

role. At weddings and other celebrations, traditional costumes are worn in ceremonies employing the ancestor culture's dances and music. This is true of Italian tarantellas in Boston, Indian *bangor* (farm and harvest) dancing in London, and Chinese New Year's parades in San Francisco. Diaspora cultures show up in new mediums too. US cable TV carries the Spanish-language channels Univision and Telemundo, with their gripping *telenovelas*; there are also stations playing Iranian and Hindu music videos.

The 1980s raised consciousness about identity politics, as many younger people with hybrid or 'hyphenated' identities used art to explore issues of racism and cultural assimilation. Paintings by African-American artist Michael Ray Charles exploited stereotypes from old magazines or advertisements, putting both black and white viewers on edge. Korean American David Chung did an installation that recreated his grandfather's convenience store in a mostly black neighbourhood of Washington, DC. Peepholes and audiotapes conveyed the ethnic suspicions on both sides.

Numerous films have proven especially effective at highlighting issues of postcolonial politics and diasporic hybrids. Spike Lee's *Do the Right Thing* foregrounded racial and ethnic tensions in the changing

urban dynamics of a modern city. Hanif Kureshi's satiric *The Buddha of Suburbia* depicted a young Anglo-Indian man's coming of age in London. *Once Were Warriors* and *The Crying Game* addressed new and evolving political–ethnic–sexual power dyamics, involving, respectively, Maori people in New Zealand and an Irish–Black–English matrix in Britain.

Another example is Mira Nair's 1991 film *Mississippi Masala*, which depicted an interracial romance in the American South between an African-American man and a young Indian woman. The ethnic background was complicated by the fact that the woman's family had been forced out of its community in Uganda by that nation's independence—the Indians had originally been brought there by British colonial rulers to build the country's railroads. Nair's film depicted difficulties in the young couple's romance caused by each ethnic group's expectations and prejudices, as well as by those of the larger culture around them.

Conclusion

What do my last two points—about postcolonial politics and diasporic hybrids—tell us about John Dewey's faith in art as a universal language? In an era of political

turmoil and complex negotiations of personal identity, even artists from within a nation, people, or culture may face difficulties in assessing meaning and value in art. A key point is that many people still see art as crucial for addressing basic questions we face—as citizens and individuals—within an ever-new, and often precarious, world situation. While recognizing that communities are internally diverse and evolving, we can still say that John Dewey's idea makes sense, that art 'expresses the life of a community'.

Dewey's remarks on art resemble Arthur Danto's theory of art (described at the end of Chapter 2 above). Dewey thought we must learn the language of art by entering into the spirit of the relevant community. And Danto argues that what artists can make as art depends upon the context of intentions possible for a given era and culture—whatever the culture *theorizes as* art. But perhaps Danto employs an overly modern and Western notion of 'art', by supposing that all cultures have something like an artworld in which they actually 'theorize' about art. The basic question is whether, if people give meaning to objects in a sensuous medium, this amounts to their having a 'theory' in an 'artworld'. Danto would say yes. In trying to show how his notion of art might apply across various cultures, Danto imagines fictitious Pot and Basket people who 'theorize' in the

sense that they draw lines in their own cultures between art and artefacts—perhaps they see pots as utilitarian and baskets as artistic. But Danto's critics argue that people in some cultures simply see no such distinction.

By contrast, Dewey's view of art seems more broad and open. It also resonates nicely with anthropologist Richard Anderson's account of art as 'culturally significant meaning, skilfully encoded in an affecting, sensuous medium'. But I have added a few details as qualifiers, so let me review three key points.

First, Dewey's advice for us to have a direct experience of the art of another culture, while attractive, is too simple. Contact with another culture's art *can* help one understand that other culture, since art is a very deep expression of attitudes and outlook. But we understand too little of either art or culture on its own, via a so-called immediate experience. Our experience will be enhanced by having what Dewey called 'external facts'.

Second, there may not be 'a' viewpoint in a culture or in that culture's art. Even though art can express a culture's values, no culture is homogenous or has gone untouched by the world. The purest-seeming instances of cultural values are often products of complex strands of interaction. Dance in Java as in Africa was affected by historical movements among local groups, as well as by more recent and repressive colonial rule. Art has always

been affected by cultural contact. This may involve imitations that at first seem crude and derivative, but that may later evolve into distinctive art forms, like Iznik tiles or Inuit print-making.

Third, art from other places and times does not always meet our own contemporary criteria for art shown in galleries and expressing individual aims or 'genius'. Art objects might be utilitarian or spiritual—or both; they might only have value in a ritual and ceremonial context, and so on. Art can be produced by a collective. It can be a garden or tea ceremony, a boomerang or seed pot, an ancestor mask or kayak, a mausoleum or coin. Anderson's definition, which refers to '. . . meaning, skilfully encoded in an affecting, sensuous medium', seems to work to encompass all this diversity.

In this chapter I have emphasized the long history of worldwide cultural interactions, and their tremendous impact on art production. What, then, is different (if anything) today, when we hear so much about the new 'global village'? One major difference involves the role of new media and telecommunications, which I will explore in Chapter 7 below. Another stems from the highly evolved international art market; this is our topic for Chapter 4.

Money, markets, museums

Cultural contact spawns attitudes from sincere respect to crass commercialism. Art and money interact in many institutions—in particular, museums. Museums preserve, collect, and educate the public and convey standards about art's value and quality—but whose standards, and how? Why were they developed, and what do they tell us about changing theories of art? In this chapter I will trace relations among artistic, educational, civic, commercial, and spiritual values.

Even small-sized cities often support an array of museums. Santa Fe, for example, has a Museum of Fine Arts, of International Folk Art, of Indian Arts and Culture, and the Georgia O'Keeffe Museum. Newer museums around the world differ from more traditional institutions by showcasing minority artists, women, and ordinary people ('folk art' includes crafts, toys, and even model train sets). These more recent

museums often combine art with anthropology and sociology. Exhibits at the Museum of Indian Arts and Culture show work 'in collaboration with Native curators, readers, artists, writers, and educators who are active partners in research, scholarship, exhibitions, and education'.

Museums and the millions

Many European and Asian museums evolved from royal collections, for instance, the Louvre in Paris, Prado in Madrid, National Palace Museum in Taiwan, Kyoto's National Museum, and the Hermitage in St Petersburg. Some museums reflect significant local archaeological finds, like the museums of Greece near Olympia and Delphi. More recently founded museums were placed in national capitals like Canberra, Johannesburg, Washington, and Ottawa, to reinforce emerging nations' self-images as champions of culture. Other museums emerged due to circumstances of local production, such as the Museum of Tiles in Lisbon. Some museums are hard to categorize because they combine regional, artistic, scientific, and medical history, like the Museum Gustavianum in Uppsala, Sweden.

Museums may reflect the identification of an artist

with a place. Georgia O'Keeffe lived in New Mexico for most of her working life, and her imagery draws upon pueblos and the desert's vast skies, flowers, and bleached animal bones. There are other single-artist museums, like Monet's house and gardens at Giverny, the Van Gogh Museum in Amsterdam, and the Warhol Museum in Pittsburgh. The siting of some museums seems rather accidental. The Folk Art Museum in Santa Fe grew from the wealth, collecting passion, and commitment of one individual, Alexander Girard, as did the Tareq Rajab Museum in Kuwait, based upon a private collection of Islamic art. Oilman J. Paul Getty sited his Villa Museum in Malibu, where he owned property.

Most early museums purported to be for everyone, but museums of more recent vintage can seem partisan. Museums like the National Museum for Women in the Arts, or museums of African-American art, Jewish museums, Hispanic museums, etc., have been called 'tribal' museums. It almost seems as if every group has (or wants) their own art museum. Arthur Danto has explored this 'Balkanizing' of the museum in his article, 'Museums and the Thirsting Millions'. Minority groups argue that new museums are needed because *their* artists, tastes, and values have not been represented in mainstream museums. (These same people might point out that philosopher David Hume's 'standard of taste'

of 'educated men' simply reflected parochial cultural norms.) In response, the older museums have tried to broaden their collections and audiences. They schedule shows devoted to minority art; instead of string quartets playing at openings, one may find African drummers and dancers. But art museums are still seen as elitist institutions. Across Europe and North America, attendance averages no more than 22 per cent of the population, and this group is skewed towards higher income brackets and educational backgrounds.

Taste and privilege

French sociologist Pierre Bourdieu has studied taste in relation to socio-economic class and 'educational capital'. His aim was to give 'a scientific answer to the old questions of Kant's critique of judgment, by seeking in the structure of the social classes the basis of the systems of classification which . . . designate the objects of aesthetic enjoyment'. As reported in his book *Distinction: A Cultural Critique of the Judgment of Taste*, the results are complicated, especially since class assessments are difficult to generalize from one nation (France) to others. But Bourdieu uncovered clear links between class and preferences in art, music, film, and theatre.

For instance, people from a lower class background preferred fewer classical composers than people in the higher economic, professional, and educational brackets. These same patterns were repeated in studies about people's preferences for avant-garde theatre or independent 'art' films. Bourdieu sums up: 'Taste classifies, and it classifies the classifier'.

In the United States people are reluctant to admit that class exists and matters. But differences are recognized and even underlie plots of famous Hollywood films like *Pretty Woman*. This movie (an updated version of *Pygmalion*) depicts the class transformation of a beautiful prostitute (Julia Roberts) who meets and marries a successful businessman (Richard Gere). The rich sophisticated hero teaches the crude, gum-chewing prostitute not only how to dress, speak, and walk, but also how to appreciate the finer things in life—like opera. Enjoyment of opera in films is always a dead giveaway of upper-class status, whereas a liking for country-western music shows the opposite—that a person is earthy or a redneck.

Artistic taste has also been studied by artists Vitaly Komar and Alexander Melamid, supported in part by *The Nation* magazine. Tongue firmly in cheek, the artist pair have created what they label 'America's (or China's or Kenya's) *Most Wanted Painting*'. Their research

reveals surprising global similarities: a dislike for abstract art and the colour chartreuse, and a preference for blue and for realistic landscapes. Their painting of what Americans want in art is a landscape with water and mountains, whose predominant colour is blue (44 per cent in fact), showing a wild animal and a historical subject. The result looks absurd: within a tranquil landscape we see George Washington dead-centre, looking lost near a wide river while deer wander nearby!

Obviously, painting by prescription does not produce a masterpiece. But there have always been successful artists who tap into what Bourdieu would call 'low' taste, which Clement Greenberg famously called *kitsch*: something vulgar and popular with great mass appeal. An older example of kitsch would be Norman Rockwell's *Saturday Evening Post* covers depicting scenes of small-town life and happy family gatherings. More recently there is Thomas Kinkade, the self-designated 'Painter of Light' (Trademarked). In Kinkade's paintings, cosy bungalows or white churches welcome the viewer with bright golden windows. Cottages sit in gardens dripping with trellised roses beside shores lapped by frothy waves. Kinkade's images are produced in a huge variety of marketable formats, including seven series of limited editions, as well as calendars, tapestries, coasters, coffee mugs, stationery, and Hallmark cards. This kitsch has

caught on and is collected by people with a rather high average annual income of $80,000. It is featured in galleries across the United States, advertised on TV, and even traded on the New York Stock Exchange.

We can all think of other examples of popular art, whether middle-brow or kitsch, from Surrealism and Tiffany lamps to paintings of Elvis in Day-Glo colour on black velvet or of small children wearing Harlequin costumes. Does the public have no real choice between vulgar kitsch and alienating avant-garde work? Must it be *either* Thomas Kinkade's villages *or* Damien Hirst's sharks? Museums may not be able to stick either to 'quality' in Old Masters' works or to the newer avant-garde 'esoteric' art, if they must cater to audiences and pay allegiance to 'tribal' preferences.

Museums and the public

The first public museum was created by the overthrow of the French monarchy after the Revolution, when the people nationalized the Louvre in 1793. Later museums were built up from donations of private collections, like London's National Portrait Gallery and the United State's National Gallery of Art. Some European institutions, like the British Museum, were

originally very restrictive, requiring references and
allowing only 'gentlemen' to visit. But there were alter-
native attempts to make art available to the public, like
the Whitechapel Picture Gallery in London's East End,
which opened in 1881. It was devoted explicitly to
urban renewal in this notorious slum region of the city.

Museums promoted national identification and sym-
bolized a nation's might. The great museums of Britain
and France represented archaeological excavations—
some would say 'raids'—on the treasures of ancient
Greece, Assyria, and Egypt. (Greece is still urging
Britain to return the famous Elgin Marbles that were
originally part of the Parthenon friezes.) Citizens of the
New World sought to legitimate young democratic
nations by recalling a grander, classical past: museums
in both Sydney, Australia and Washington, DC take the
form of Greek temples with classical columns and
domes. Sales of 'national' art treasures to wealthy
foreigners have led to hard feelings. Getty provoked
Dutch ire by buying an important Rembrandt portrait,
Marten Looten, in 1932 (when prices were depreciated
by the imminent onset of World War II).

Danto's article on 'tribalized' museums with the
'thirsting millions' in its title refers to Henry James's
novel *The Golden Bowl*, in which a rich American collects
European art to take home for a museum that will

civilize 'the thirsting millions'. This scenario is not a figment of Henry James's imagination. The earliest North American museums were founded in the 1870s by wealthy individuals in northern centres of culture, industry, and government (Boston, New York, and Chicago) partly to enlighten working classes and immigrants to their cities.

A similar 'civilizing' intention was at work in the founding of the National Gallery in the early part of the twentieth century. Andrew Mellon, Secretary of the Treasury under President Hoover, was embarrassed when foreign diplomats came to town and asked to be taken to the 'national gallery'. Mellon built the museum (opened in 1937) from his own collection, seeking complementary collections from donors like Samuel H. Kress. The Gallery's first director, David Finley, describes the museum's civilizing effects when it was first open during World War II and became a haven for soldiers visiting the city ('warm in winter and cool in summer, with a good cafeteria and, incidentally, interesting pictures'). Free Sunday concerts, like the spacious galleries and the new practice of selling art reproductions, were all aimed to promote an appreciation of beauty and quality among the ordinary men and women of the military.

Of course, wealthy American industrialists also

collected art to prove their *own* cultural standing in relation to the older European aristocracy. As John Dewey commented in 1934, 'Generally speaking, the typical collector is the typical capitalist. For evidence of good standing in the realm of higher culture, he amasses painting, statuary, and artistic *bijoux*, as his stocks and bonds certify to his standing in the economic world'. J. Paul Getty's 1976 autobiography *As I See It* rather painfully reveals his obsession with art of European royal palaces. His tales of collecting are in each case accounts of how much he spent. A biographer notes that many people who aided Getty in his collecting felt he really wanted things he considered bargains: 'He would study the X-rays of a painting to determine its origin but reject it if the cost per square inch seemed too high'.

Getty's Villa Museum in Malibu is modelled after a patrician Roman's pleasure palace in Herculaneum on the Bay of Naples. He even remarked, 'I feel no qualms or reticence about likening the Getty Oil Company to an Empire—and myself to a Caesar'. Getty, like earlier philanthropists, spoke of improving the masses: 'Twentieth-century barbarians cannot be transformed into cultured, civilized human beings until they acquire an appreciation and love for art'. But his autobiography does not mention the tax shelter advantages

13 The J. Paul Getty Villa Museum in Malibu (seen here in a courtyard view) was a careful recreation of an ancient Roman pleasure palace.

of his museum and foundation, which were hardly negligible.

The latest mega-bucks art investors include moguls in new fields of high finance, like advertising and computer software. Ad executive Charles Saatchi is a major player in contemporary art trends. In the book *Young British Art: The Saatchi Decade*, Saatchi gets more featured billing than any of the controversial artists (like Damien Hirst) whom he supports. This humongous book (600+ pages, $125) includes essays and full-colour images alongside fuchsia-tinted tabloid articles touting or doubting the wisdom of the man behind the *Sensation* exhibit. Headlines scream about the 'Trouble with Saatchi', or ask 'Has Saatchi Lost His Touch?' But two major messages are conveyed, so that this book amounts to a giant spin job—of a nation, with slogans like 'True Brit' and 'Britain is Best'; and of an individual, with repeated mention of how the ad-man has donated 100 works to the British Arts Council.

Finally, we cannot omit mention of the world's new richest man, Microsoft founder and billionaire Bill Gates. Gates has purchased major photographic collections and owns Leonardo's important work the *Codex Leicester*. Gates's spin-off company Corbis, founded in 1989, has spent over $100 million to purchase rights to reproduce images from the Louvre,

Hermitage, London's National Gallery, and the Detroit Institute of Art. By 1997 Corbis had scanned one million images into digital form. Ultimately, the aim is to provide art for people's homes in the form of high-resolution images beamed onto new, super-flat large screens. Reportedly, Gates has explored using such systems in his multi-million dollar home to enable visitors to adjust the art in rooms they enter to their own taste. But for now, Corbis offers to 'put the Hermitage and the Louvre on your desktop' in the form of screen savers, backgrounds, and electronic postcards, complemented by the more traditional options of prints and posters.

From philanthropists to corporations

Since around 1965 a shift has occurred in museum funding, away from private philanthropists; in 1992, almost $700 million was given by corporations to promote culture and the arts. The earliest corporations to provide major funding to museums were tobacco and oil companies, which likely sought to polish tarnished images by supporting 'culture'. The shift to corporate sources coincides with the rise of the 'blockbuster' exhibition, where funders expect a lot of 'bang for their bucks'. Blockbuster exhibitions like *Treasures of*

Tutankhamen, *Pompeii*, and *Jewels of the Romanovs* aim at broad public appeal and middle-class taste. But if a corporation is funding an exhibit, museum directors and curators may feel restricted in what kinds of art can and cannot be shown. Metropolitan Museum of Art director Phillipe de Montebello speaks of 'a hidden form of censorship—self-censorship' in the museum world.

Foreign corporations also fund art exhibits to grease the wheels of international relations and commerce. Major shows of work from Turkey, Indonesia, Mexico, and India have been discussed by Brian Wallis in an article with the apt title, 'Selling Nations: International Exhibitions and Cultural Diplomacy'. Government-sponsored art loans may be arranged in order to promote a nation's image overseas, attracting investments and favourable foreign relations policies. As Wallis explains, '[I]ndividual nations are compelled to dramatize conventionalized versions of their national images, asserting past glories and amplifying stereotypical differences'.

Museum's changing purposes

Changing patterns of funding have combined with the competing claims of 'tribal' groups to challenge the aims

and values of art museums. Philosopher Hilde Hein has described a quandary museums face in identifying their chief function: as repositories of valuable *objects*, or instead, as places to produce interesting *experiences*. The aims of scholarship and preservation of real objects are being displaced by an emphasis on virtual experiences, theatricality, and emotional rhetoric. Museums are bedecked as entertainment palaces, à la Disneyland, when they add jazzy modes of presentation, audio-phone tapes, fancy displays with buttons and videos, mega-gift shops, etc. At a major Diego Rivera exhibition in 1999, the shop featured not just the usual array of artist postcards, books, posters, and a catalogue, but an entire *mercado* of 'Mexican' items: dolls, Oaxacan wood carvings, earrings, miniature piñatas, and other trinkets.

Museums are the primary contemporary institutions upholding classical standards of artistic value. Recent years have seen more and more attention to how their physical arrangements affect this value—or to 'the politics of museum display'. The Pompidou Centre (Beaubourg) was revolutionary and attracted many kinds of audiences with add-ons such as cafes, restaur-ants, bookstores, theatres, a film section, etc.

Museum displays clearly affect perception of art-works. In the last chapter we saw anthropologist James Clifford's description of how various museums in the

Canadian northwest provide different interpretations and assessments of Kwakiutl art through their displays. Curator Susan Vogel of the Center for African Art in New York arranged an exhibit in 1988 entitled *Art/artifact,* using varied display techniques to provoke visitors to ponder distinctions between art and non-art. Objects like masks and memorial posts were spotlit and isolated in a 'high modernist art' treatment, and then shown with models of human figures in natural history 'human dioramas', or crammed together in the style of an anthropological museum. Display methods altered viewers' perceptions, even causing people to seek the high art value of something like a mundane and inexpensive fishing net.

What *should be* the mood of a museum visit? Is it like going on a picnic, to school, on a shopping trip, or to church? Is money the name of the game, an inescapable fact about art today? Let me conclude this topic by looking at inflation in the art market and artistic attempts to escape it.

What's a poor artist to do?

No chapter on art and money can be complete without mention of astronomical prices paid at art auctions,

14 Vincent Van Gogh's *Irises* (1889) was sold to a Japanese collector in 1987 for $53.9 million; it is now in the Getty collection.

This reproduction cannot convey the large size and glowing colours of Andres Serrano's *Piss Christ* (1987), the image that stirred a furore over US arts funding.

I

Iznik Tiles: Late 16th-century polychrome decorations illustrate borrowings from Chinese porcelains in stylized designs of tulips, roses, and chrysanthemums.

Huichol Art: Butterfly and votive bowls are decorated through carefully placing individual beads in pine resin on a wooden frame or gourds. Artists unknown.

Barry McGee's installation *Hoss* (1999) used layered paint and graffiti to evoke urban street life in an art gallery setting.

A Tibetan monk begins the ritual process of erasing a mandala painting; later the coloured sand from the painting will be emptied into a nearby body of water to lend powers of purification.

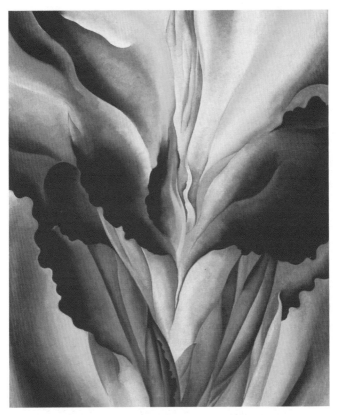

Georgia O'Keeffe's *Red Canna* (1923) is an example of why her flower paintings are sometimes seen as erotic and sexual.

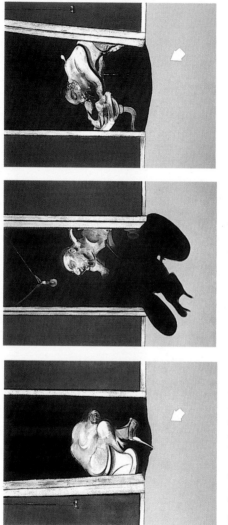

The bat-shaped dark shadow under the central figure in Francis Bacon's *Triptych* (May–June 1973) hints at death.

Bill Viola's video *Chott el-Djerid* meditated upon the astonishing visual effects (even mirages!) produced by the extreme climactic conditions of deserts and wintry prairies.

An image from *Jonah and the WWWhale* (1999), a 'Biblical Techno-Fantasy', by Jim Clarage and dadaNetCircus.

especially in the boom years of the 1980s. Prices of Van Gogh's works at sales in 1987, in particular, stunned the world: his *Irises* sold for $53.9 million and *Sunflowers* for $39.9 million. In the same year, two of Van Gogh's other works went for $20 million and $13.75 million. The irony was grotesque in light of the artist's own poverty and despair over being unable to sell works during his lifetime. The thought that a work like the *Mona Lisa* is 'priceless' makes it difficult to see and appreciate as art (when one is lucky enough to get a second to stand before it). Can we ever again see Van Gogh's works as art rather than as huge dollar signs?

Sometimes a museum capitalizes on our absorption with money. A membership solicitation brochure for Australia's National Gallery of Art from 1995 featured the controversy over its purchase of Jackson Pollock's painting *Blue Poles*. The brochure's cover showed a huge tabloid headline that denounced the painting: 'Drunks Did It!' But, on the inside of the brochure, the museum (and presumably its members) got the last laugh by pronouncing, 'Now the world thinks it's worth over $20 million. And it's all yours from $14.50 (i.e., the price of a membership)'. After succumbing to this appeal, will the new museum member really be able to look at *Blue Poles* for its artistic value?

Museums are only a part of the current story of the

art market, because wealthy collectors worldwide have more buying power. Charles Saatchi has been accused of manipulating the market for the latest young and trendy artists through his sudden shifts in purchases or sales. His support of exhibitions like the controversial *Sensation* show of young 'Britpack' artists has been criticized: through promoting the exhibition, Saatchi raises the value of works that his gallery owns.

How can an artist escape or confront the art market, with its vagaries of trends and fickle favour? Some take money as their subject matter by sculpting or painting it, even including real money in their art. Installation artist Ann Hamilton's huge room-sized project, *Privation and Excess*, in San Francisco's Capp Street Gallery, 1989, used thousands of pennies—tons' worth—encased in honey, highlighting both their colour and sheen to allude to complex notions of hoarding and value. Artist J. S. Boggs makes a living by drawing very realistic copies of US currency—always indicating somewhere that the bill is not real. His skill is enough to fascinate people into taking the money as payment for, say, a trip to a coffee shop. He later finds patrons to buy back his bills, and then exhibits them along with the original receipts for items purchased. Boggs's status as an artist has not enabled him to escape without frequent run-ins from the counterfeiting police!

15 This membership brochure for the National Gallery of Australia traded on the controversy about the museum's purchase of Jackson Pollock's painting *Blue Poles* (1952). See also overleaf.

Now the world thinks it's worth over $20 milli◖

The Australian National Gallery in Canberra has, without question, the finest modern art collection in the Southern Hemisphere. And Blue Poles person that you are, an opportunity for a modest philanthropic gesture. Please don't. The <u>advantages</u> that Membership offers are a bargain in 4. Free bi-monthly magazine. F◖ of useful articles on works in th◖ National Collection and news of for◖ coming Gallery exhibitions and spec◖

SPECIAL LI◖
SIX MONTHS FR◖
ACT ◖

And it's all yours from $14.50.*

JACKSON POLLOCK Blue Poles 1952

see such a representative collection of Aboriginal and Australian art from its earliest beginnings to the present.

Nowhere else will you see such a collection of art from Oceania, Africa and the Americas.

Nowhere else will you see such a comprehensive range of media: photography, film, graphic arts, theatre art and fashion, worldwide.

Nowhere else will you see a collection that so wonderfully represents the achievements of 20th Century art.

And, to encourage you to get the most out of this national treasure house, we are making an extraordinary offer to new Members which you will find in this brochure.

10. Five free Guest Passes (worth ¼ each year.

11. Automatic invitations in your te to the Australian National

many different and always attractive holiday package offers.

These benefits are available to Members only, at any Thomas Cook

HIGHER LEVEL MEMBERSHIP BRINGS NEW BENEFITS.

You'll notice that Higher Level Membership is also available.

Some artists bypass the market by using alternative forms, such as installation and performance art, which are not readily packaged for sale. Graffiti artists, with their strike-and-vanish tactics, seem to reject the gallery system altogether. But some of them who have risen to fame, like Jean-Michel Basquiat and Barry McGee, get caught up in the system when their work becomes marketable. McGee is trying to toe a fine line between his street work with the signature 'Twist' and signed gallery art that sells (see Plate III). His work has been shown in galleries from San Francisco to Minneapolis to São Paulo. I confess to fomenting some wicked plans for the gallery's windows when I read in a catalogue essay at one of his art exhibitions that McGee once said, 'Sometimes a rock soaring through a plate of glass can be the most beautiful, compelling work of art I have ever seen'.

German artist Hans Haacke has made commercialization and corporate support of art exhibitions the central subject of his work. Haacke's dry, scathing exhibitions juxtapose the cultural sponsorship brought to you by corporations like Mobil and Cartier with their nefarious activities in troubled regions of the world. Haacke's project, *Voici Alcan* in 1983, for example, juxtaposed images of the Alcan Corporation's logo framing scenes of famous opera productions it had supported with a similar 'ad-style' image showing the

graphic close-up face of the dead liberationist leader Stephen Biko in South Africa. Haacke's plans for work that denounced a slum landlord with shady real estate dealings was cancelled six weeks before it was scheduled to be shown in 1971 at New York's Guggenheim Museum. Speculation was that the property owner's friends on the Board of Trustees arranged the cancellation of this planned exhibit.

The irony here again, as with McGee, is that the system often seeks to consume even its harshest critics. Benjamin Buchloch championed Haacke in a 16-page cover story for the glossy magazine *Art in America* in February 1988. In a lengthy footnote, Buchloch insisted that Haacke is 'marginalized'—despite the artist's increasing prominence and marketability. One work of Haacke's had recently sold in auction at Christie's for what even Buchloch admitted was the 'rather impressive price of slightly more than $90,000'! Setting these financial ironies aside (along with Buchloch's laboured account of how the artist rejects 'aesthetic autonomy and pleasure'), I simply find Haacke's work too preachy and boring. It is also ephemeral, and risks losing its punch when the context alters. Visually stronger work like Goya's *The Executions of May 3, 1808* retains its power to disturb us long after the specific political scene has changed; it is not clear that Haacke's didactic

16 Christo and Jeanne-Claude, *Running Fence, Sonoma and Marin Counties, California,* 1972–1976, exemplifies the couple's ephemeral yet beautiful interventions in a natural landscape.

wall texts, shown in a uniform series of panels, will do this.

There are other models of how (not to) make money from art. American artists Christo and Jeanne-Claude make art that is deliberately transitory and cannot be sold. They travel the world, conceiving and executing huge landscape and environmental installation projects. Best known are their *Running Fence* (1972–1976) in California, *The Pont Neuf Wrapped* in Paris (1975–1985), and the gaily skirted bright pink *Surrounded Islands* in Miami Bay (1980–1983). In their *Umbrellas* project (1984–1991), carried out both in Japan (with blue umbrellas) and California (with yellow umbrellas), the couple undertook to link the natural landscapes of river and mountains not only across the two nations but also to the artificial landscapes of freeways, by making the work visible across miles. Getting permission and collaborative support becomes part of the art project, and the pair derive no income from photographs, books, posters, postcards, and films. They pay all the expenses of the project with their own money coming from the sale of preparatory drawings, collages, scale models, all created before the completion of a project.

Perhaps the strongest examples of anti-commercialism in art are Tibetan Buddhist sacred paintings done from coloured sand, not as a permanent

product, nor really even as art (see Plate IV). The detailed mandalas are constructed by monks in a painstaking process over days, producing the image of a sacred scene as an aid to meditation. Once complete, the image is ritually erased and the sand scattered (preferably into a body of water) to effect cleansing and purification. The work's impermanence epitomizes the Buddhist view of life's transitory nature. Obviously these paintings are religious and are not done to sell a product. Still, when undertaken in a major museum, the context suggests that the project *is*, after all, a kind of art. Recent appearances by Tibetan sand-painters have carried clear political messages, as the monks seek to glean American or Canadian support during Tibetan repression by China. And there is also some sort of underlying financial structure at work. When I saw the monks, their room included not only altars to Buddha with flowers and incense, but also a money jar for donations to help their monastery in India and to aid Tibetan refugees.

Public art

I have so far emphasized museums and the impact of corporations, groups, nations, and wealthy individuals

upon the art market. But some art takes place outside this nexus, using public or government funding. One example is the public art project *Culture in Action* in Chicago in the summer of 1993. This project, supported by the NEA, took art into the city's streets and neighbourhoods. One of the projects even involved an artist working with a labour union at a factory to produce a new candy bar, 'We Got It!', as art. A hydroponic garden grew vegetables and served as an educational centre for people with Aids. Iñigo Manglano-Ovalle's *Tele-Vecindario: A Street-Level Video Project* was organized in his own Latino neighbourhood, West Town, to address problems of youth gangs. The artist helped kids create their own video documentaries, then organized with the neighbourhood, using power from every house, to create a 'Block Party' installation on an empty lot. It combined multiple monitors in a striking, somewhat surreal sculptural assembly. The *Culture in Action* exhibition did seem to engage the entire city. And the street video project has been continued at a neighbourhood drop-in centre for kids.

Public projects like this one are successors of earlier efforts to bring art to the so-called masses. There have been other means besides bringing people into the elite museums full of 'quality' art, or by bringing artists out into the city—as if to show the workers their daily

17 One scene from Chicago's *Culture in Action*: kids assembled TV monitors and power cords from their neighbourhood to exhibit their videos in Iñigo Manglano-Ovalle's *Street-Level Video, Block Party/Installation, Chicago, 1994.*

drudgery is more meaningful if it becomes 'artistic' and 'creative'. Situationism International was a Marxist-influenced movement in Europe in the late 1950s and 1960s that aimed to overthrow elites and intellectuals by using street theatre and dada-style gestures. Some would say it culminated in the French student resistance protests of May 1968, with echoes later in the US student protest movements. Perhaps it appears today in certain phenomena of street art, punks, and particular bands. Similarly, the Arts and Crafts Movement, propelled by figures in England like John Ruskin and William Morris, aimed to enhance people's everyday experiences by bringing beauty to their usual aesthetic surroundings, including all aspects of the home, from architectural styles to furniture, lamps, textiles, dishes, and utensils.

The effects of the Arts and Crafts movement could not have been altogether unknown to John Dewey, who advocated the enrichment of ordinary experience of the organism or 'live creature' in its environment. He deplored the current urban landscape of his time, both its slums and wealthy apartments, as 'destitute of imagination', just as he rejected the view of art as 'the beauty parlor of civilization'. We might worry that the 'beauty parlor' view is itself sometimes adopted, by either museums or radical movements, when they

arrange for people to escape their usual environment: to go somewhere, look at something, find someone, buy something, or be taught by someone to see something ordinary—whether a garden, graffiti, highway, or candy bar—as art. Even 'tribal' art museums, which are allegedly for everyone, do still tend to hang on their walls the work by only a specialized few from the tribe— their 'artists'.

Dewey actually called for more, a revolution 'affecting the imagination and emotions of man'. He felt that 'the values that lead to production and intelligent enjoyment of art have to be incorporated into the system of social relationships'. Had Dewey been able to witness the *Street-Level Video Project* for *Culture in Action*, in the city of Chicago, where he spent most of his working life, he probably would have approved it, seeing it as having much in common with the social reform efforts of his friend Jane Addams at Hull House. The labour union-produced candy bar as art is another story, though; Dewey probably would doubt it had any real, lingering impact. It seems regrettable that Dewey's words from 1934 still ring true today:

> The hostility to association of fine art with normal processes of living is a pathetic, even a tragic, commentary on life as it is ordinarily lived. Only because that life is usually so stunted, aborted, slack, or heavy laden, is the

idea entertained that there is some inherent antagon-
ism between the process of normal living and creation
and enjoyment of works of esthetic art. After all, even
though 'spiritual' and 'material' are separated and set
in opposition to one another, there must be conditions
through which the ideal is capable of embodiment and
realization. . . .

5

Gender, genius, and Guerrilla Girls

inority groups have begun to create art institutions of their own, and among these groups are women—not a minority in the population, but a definite minority in standard histories of art. Feminism has had a major impact in other spheres, so it is not surprising to find it in art theory too. One of the best-known women painters, Georgia O'Keeffe, always resisted the label 'woman artist'. By contrast, Judy Chicago was aggressively female in *The Dinner Party*, the 1979 work which helped launch the feminist art movement. Her triangular dinner table installation celebrated prominent women at place settings done in traditionally 'female' mediums of embroidery and china painting, each plate adorned with vaginal imagery of fruits and flowers. The controversial *Dinner Party* is now homeless, dismantled, and in storage. It is even scorned by many feminists as 'essentialist'—too closely

tied to conceptions of an allegedly universal female biology.

Is gender relevant to art—to work an artist makes, or to meaning? What about sexual orientation? Robert Mapplethorpe flaunted his sexual preferences in his art. But what about artists from the past, like Leonardo? Recent scholarship suggests that composer Franz Schubert was gay; but, as one news story covering a 1992 musicology conference asked, 'If he was, so what?' It seems that some people think it matters—though why, and whether for good reasons, remains to be seen. This chapter addresses the relevance of gender and sexuality to art.

Gorilla tactics

In 1985 a group of women artists in New York organized to protest against sexism in the art world. The 'Guerrilla Girls' hid their identity under furry gorilla masks. Apart from their unique headgear, they dressed conventionally in black attire, even in short skirts with high heels. To complement their saucy use of the label 'girls', the 'G-Girls' created billboard-style posters using bold black text and graphics that grab the viewer's attention. Plus, they used humour—to show that feminists do have some!

18 This Guerrilla Girls ad explains where to find women in a museum: *How Women Get Maximum Exposure,* 1989.

One Guerrilla Girls' ad, 'How women get maximum exposure' (1989), done in vivid (banana) yellow, depicted an Ingres reclining nude topped by a big gorilla head. Underneath, the text asked, 'Do women have to be naked to get in the Met?' The poster said that only 5 per cent of the artists in the modern section of the Metropolitan Museum are female, compared to 85 per cent of the nudes. Another poster listed 'Advantages of being a woman artist', such as 'not having to deal with the pressure of success'. Yet another poster listed more than 60 female and minority artists and told the art buyer that he could have acquired one from each for the $17.7 million spent on a Jasper Johns painting.

The Guerrilla Girls' ads are published in magazines, pasted up as street signage or slapped onto bathroom walls in museums and theatres. Some ads lampoon prestigious galleries and curators. They satirized a 1997 still-life exhibit at MoMA which featured only four women among 71 artists. The Girls believe their posters have had an impact: '[Gallery owner] Mary Boone is too macho to admit we influenced her in any way, but she never represented any women until we targeted her'. To point out sexism in other fields, they have protested the absence of women in theatre's Tony awards: only 8 per cent of the plays produced on Broadway were written by women. Several of their ads underscore the absence of

women as film directors. One poster reshaped the Oscar award statuette to look more like the men who actually receive him, showing the once-sleek golden man as portly, slump-shouldered, and pale.

The 'Girls' recently published their own art history, *The Guerrilla Girls' Bedside Companion to the History of Western Art* (1998). It argues, with humour and satire, that more women should be included in standard art histories and in museums. The ex-slave Harriet Powers was using African symbolism in quilts based on Biblical themes in the early part of this century, before Picasso and Matisse, so the 'Girls' demand that all modern art curators now take crash courses in the history of quilting. The G-Girls also decry the fact that Georgia O'Keeffe's sexual flower imagery gets described by male critics in terms that make her sound like a 'sex-obsessed nymphomaniac', whereas, 'When a guy shows his libido in his art, it's usually thought of as a noble gift to the world that is really about larger philosophic and aesthetic ideas'.

No great women artists?

Some of the problems the Guerrilla Girls identify have been addressed by more conventional art theorists.

Linda Nochlin wrote an influential essay in 1971 'Why Have There Been No Great Women Artists?', where she noted:

> There *are* no women equivalents for Michelangelo or Rembrandt, Delacroix or Cézanne, Picasso or Matisse, or even, in very recent times, for de Kooning or Warhol, any more than there are black American equivalents for the same.

Nochlin knew of women artists in the past, like Rosa Bonheur and Suzanne Valadon—even of famous ones like Helen Frankenthaler. We might defend their greatness or 'equivalence' to male artists. But Nochlin thought it would be hard to find female parallels to the greatest male artists, and this inspired her essay. She also pointed out that good women artists had nothing special in common as women—no 'essence' of femininity linked their styles.

To explain female absences from art, remember the social and economic facts of women's lives in the past. It is what Nochlin calls a 'myth of the Great Artist' to imagine that greatness will be manifested no matter what the surrounding circumstances. Artists need training and materials. Famous painters often came from specific social groups, and many had artist fathers who supported and encouraged their sons' interest in art.

And far fewer fathers did this with daughters (but in fact, most of the women who did become painters had artist fathers). Art required both patronage (which women artists were unlikely to win) and academic training (from which women were barred). Through much of the past, strict social expectations about women's roles in family life discouraged them from seeing art as more than a hobby. Nochlin concluded that women must 'face up to the reality of their history and of their present situation, without making excuses or puffing mediocrity'.

Even where women's contributions have been recognized—for example, in various kinds of American art pottery—the artists still experienced restrictions and discrimination. Both the great San Ildefonso potter Maria Martinez and the Hopi potter Nampeyo made pottery while attending to household chores, child-care, and the significant ritual responsibilities of Pueblo ceremonial society. Sometimes women's ambition in their art was restricted by their own sense of what is appropriate to their gender, or by internalized sexism. For example, Adelaide Alsop Robineau, who carried the torch of the Arts and Crafts Movement into the United States, wrote words in her magazine *Keramic Studio* in 1913 that make us cringe today:

[A]s in the spring a young man's fancy lightly turns to thoughts of love, so in this new spring time of ceramic opportunity, the young woman's fancy will turn . . . to thoughts of the beautiful things she can now make to keep the young man's fancy fixed, if not on thoughts of love, at least on thoughts of the attractiveness of food served up in dishes decorated with these new and lovely designs and colors. . . . For after all eating is the chief end of man, and man is the chief interest of woman, in spite of these days of suffragettes and politics.

Gender and genius

Since 1971, when Nochlin wrote her essay, many more women artists have been recognized as important. In fact, the MacArthur Foundation, which annually funds 'genius awards', has given out quite a few to women artists. Georgia O'Keeffe now has her own museum (in Santa Fe), and since 1990 there has been a National Museum of Women in the Arts in Washington, DC. Women photographers and artists such as Cindy Sherman, Barbara Kruger, and Jenny Holzer, working in new media like photography, neon signs, and LED panels, have achieved fame and international recognition. We could say that the social conditions have changed enormously to facilitate more female participation in

the arts and greater recognition of women artists' merits. But some people might suspect instead we have watered down or altered old notions of greatness and genius.

Let us go back into the origins of the use of this term ('genius') to apply to art. Genius, you may recall, was something that Kant invoked in his *Critique of Judgment* to label the mysterious quality in an artist that enabled him (*sic*) to create work with beauty. 'Genius' is what 'gives the rule to art', meaning that an artist somehow can make materials come together into a form that is recognizably beautiful to viewers, setting the example for later artists to follow. But there is no rule to predict or explain how people can do this—it's just their genius. The sculptor who made the famous Laocöon grouping showing a scene from Greek mythology, where a man and his two young sons struggle, about to be devoured by snakes, showed genius in capturing emotion in formed stone.

Kant did not know about Cubism or Abstract Expressionism, of course, but he might make similar points about why a particular Picasso or Pollock painting is beautiful or shows genius. Such paintings are pathbreaking in the way they reshape our perceptions. Genius belongs to creators who employ their medium so that all viewers can respond with awe and admiration.

Genius is often cited to excuse or justify an artist's strange behaviour (Van Gogh's cutting off his ear), abandonment of ordinary obligations (Gauguin's running off to Tahiti), or alcoholism, womanizing, and mood swings (Pollock). It is difficult to imagine a woman in the 1950s getting away with Pollock's bad boy antics, like urinating into Peggy Guggenheim's fireplace when a crowd was gathered to see one of his paintings.

In a study of how the notion of genius evolved, *Gender and Genius*, Christine Battersby argues that 'genius' came into its modern use only towards the end of the eighteenth century. In this time period people revised both Renaissance and ancient views of men's and women's natures. The late medieval picture of lustful woman (think of the Wife of Bath in Chaucer's *Canterbury Tales*) was replaced by a view of woman as pure and gentle. Perhaps strangely, the male became more associated with a set of qualities including not just reason but also imagination and passion. Genius was now seen as something 'primitive', 'natural', and unexplained by reason. It was almost like a creative fit to which the artist (whether Shakespeare, Mozart, or Van Gogh) was subject as art flooded from his very pores. As the notion of genius got tied to *men*, there were peculiar shifts and diagnoses: Rousseau denied that women could be geniuses because they lack the requisite

passion, but Kant reversed things by insisting that genius obeys a sort of law or inner duty, and claiming that women lacked such discipline on their emotions—they must derive it from their husbands or fathers!

Canons away

By challenging the exclusion of women from lists of great artists or musicians, feminists are questioning the *canon* in these fields. The canon in art or music is the list of 'great' people or 'geniuses' that made their mark in that field. In art it would include Michelangelo, David, and Picasso; in music Bach, Beethoven, and Brahms. The term derives from the ancient Greek word *kanon*, which designated a straight rod, ruler, or exemplary model. Canons in a field get entrenched: they appear everywhere, in courses, textbooks, bibliographies, institutions. They reinforce the public's view about what counts as 'quality' in a field. Feminists criticize canons because they enshrine traditional ideas about what makes for 'greatness' in art, literature, music, etc; and this 'greatness' always seems to exclude women.

There are two main types of feminist critique of canons. The option chosen by the Guerrilla Girls in their revisionist history can be called the 'Add Women

and Stir' approach. These feminists' goal is to include more women in the canon of great and important art. This involves research to uncover lost or forgotten great women in a field, or to seek 'Foremothers'—as the Guerrilla Girls look to find lesbian or minority artists whose work deserves more study and recognition. The second option is to do a more radical re-examination of the whole idea of a canon (or, 'Down with Hierarchy!'). The feminist asks how canons have become constructed, when, and for what purposes. Canons are described as 'ideologies' or belief systems that falsely pretend to objectivity when they actually reflect power and dominance relations (in this case, the power relations of patriarchy). This second approach advocates a careful re-examination of the standards and values that contributed to formulation of the canon. What does the omission (or the exceptional inclusion) of women tell us about problems with the values in a field? Perhaps instead of creating a new and separate female canon, we need to explore what existing canons reveal.

Canon revision in art and music

The 'Add women and stir' approach shows up in some major textbooks in art and music history. Feminism has

led to increased awareness of certain painters of the past, such as Artemisia Gentileschi and Rosa Bonheur. Gentileschi survived rape and vilification in a trial where her rapist, and former teacher, was found not guilty after her own character was sullied. Some critics suggest that Artemisia 'got even' with men with her depictions of very powerful female figures such as Judith from the Bible, beheading the foul man Holofernes. Artemisia's Judith is not a delicate flower who recoils from her task, but a muscular woman who boldly does the deed amid spurting blood. Similarly, Rosa Bonheur actually had to get legal permission to wear trousers while trudging through muddy streets of Paris to visit slaughterhouses and horse stables for her animal studies. She flourished as an artist and was successfully unconventional, never marrying but sharing her life with a female companion.

When Nochlin wrote her article back in 1971, standard histories of art, like E. H. Gombrich's *The Story of Art* and H. W. Janson's *History of Art*, mentioned no women artists by name. (Janson even had an Introduction called 'The Artist and His Public'.) Janson's book continues to be prominent; *History of Art* is used in college classrooms across the United States. In its present fifth and revised edition (1995), the text mentions and reproduces works by many contemporary women

painters, such as Lee Krasner (Jackson Pollock's wife), Audrey Flack, Elizabeth Murray, and others. Even its historical chapters include works by women, such as the Dutch flower painter Rachel Ruysch and the English portraitist Angelica Kauffmann, along with one of Rosa Bonheur's majestic horse paintings. There is even a letter by Artemisia Gentileschi in the 'Primary Sources' section. The inclusion of all these women in Janson's and other modern art history textbooks shows the impact feminism has had on the field. (Janson's Introduction is now headed, 'Art and the Artist'.) But the Guerrilla Girls still lampoon Janson's book in their own version of art history, by recreating its cover in one of their poster-style artworks, defaced by a bit of graffiti so that it reads, 'History of *Mostly Male* Art'.

Let's switch to music history. In *Gender and the Musical Canon*, Marcia J. Citron studied relatively new textbooks of music history to see how they adopted different models from standard texts of musicology. Some women composers, like Clara Schumann and Fanny Hensel, are now recognized in major texts—but not many. There are consequences of canonicity in music: just as people in the history of art books are also the ones whose works we see in museums, so also do we hear more musical performances of people in the

history of music books. Citron describes how music history is being revised, not as a history of 'great men' and 'periods', but with more attempts to focus on music's evolving social function and role.

How were women composers affected by their gender? Often they stopped writing or changed what they did when they married and began having families. To conform to rigid social expectations (or if forbidden by husbands), some gave up their work. Fanny Mendelssohn Hensel, the sister of Felix Mendelssohn, was raised in a supportive context where her mother in particular ensured that she received musical training equal to her brother's. Fanny's talent seemed great, but she was unable to publish her work—in part because her famous brother insisted it was not appropriate for a woman in her social circles to do so. Felix wrote to their mother:

> Fanny, as I know her, possesses neither the inclination nor calling for authorship. She is too much a woman for that, as is proper, and looks after her house and thinks neither about the public nor the musical world, unless that primary occupation is accomplished. Publishing would only disrupt her in these duties. . . .

Fanny Hensel's musical ability was confined to work that could be performed in salons and homes rather

than in concert halls. Similar obstacles limited the types of output of other female composers.

Citron advocates a *social* history approach that would challenge the canon in music by focusing more on how high art and popular music were differentiated, on women's roles as singers and teachers, on how audiences were constructed and expected to behave, and so on. Musicology needs to be broadened to help us understand more facets of music. We could study how women participated in it in ways that have not been seen as significant by considering 'women in the salons, women in the Church, women in the courts, women as patrons, women and the voice, women and the theater, women as music teachers, women and folk traditions, women and jazz, women and reception, etc.'

More canon blasts

It is too simple in re-examining canons of either art or music history just to find and celebrate famous fore-mothers, whether the painters Bonheur and Gentileschi, or musicians like Hildegard of Bingen and Fanny Hensel. Critics of the 'Add women and stir' approach suggest that we start over again, and look more closely at the very idea of hierarchy created by canons in art and

music. A similar approach to Citron's revisionist musicology is the book *Old Mistresses: Women, Art, and Ideology*, by Roszika Parker and Griselda Pollock. Before the rise of modern art history, earlier histories routinely *did* recognize women artists' contributions. Vasari's *Lives of the Artists*, from the Renaissance period, shows women artists were recognized for their ability and success in his time. As we just saw, our idea of 'genius' is relatively modern; in much of the past, artists were not seen as expressing deep spiritual needs or letting genius 'flow out' in their art. They were simply skilled craftspeople hired for jobs and trained through a system of apprenticeship. Art was often a family business, and some artistic families included sisters and daughters. Tintoretto's daughter Maria Robusti (1560–1590) worked as part of his studio system alongside others. She may have done many portions of his works or even entire paintings, up to the time of her early death in childbirth—always a risk for women in the past. Medieval art was also done by both men and women in varied settings. Both monks and nuns alike made tapestries and illuminated manuscripts. Queens and ladies of their courts did elaborate needlework as proof not only of ability but also of lofty social status in Renaissance England.

Parker and Pollock explain that some kinds of art, for

example flower painting, were dubbed 'feminine' for complex reasons. Women could not study nudes in the academies from the Renaissance through the nineteenth century to learn life drawing, and this blocked their participation in the all-important genre of history painting. Northern European flower paintings that were previously admired began to seem 'delicate', 'feminine', and 'weak' by contrast to large bold canvases on classical themes. Yet many male artists also have painted flowers: think of Monet's water lilies and Van Gogh's *Irises* and *Sunflowers.* So what makes a flower painting 'feminine'? Parker and Pollock trace the origins of prejudice to art historians who see both flowers and females as natural, delicate, and beautiful. Their attitude ignores the content and skill of flower painters. In some periods or regions, flower paintings epitomized high art, and their artists were honoured—viewers knew that bouquets in Dutch still-lifes by Maria Oosterwijk and Rachel Ruysch had symbolic meaning as part of *vanitas* images. Many artists and scientists alike treasured the seventeenth-century flower paintings of Maria Sibylla Merian, who made important contributions to botanical and zoological taxonomy with her detailed, careful studies.

A second example concerns twentieth-century textiles and fabric art. Certain textile arts like Navajo rugs

were often hailed as exquisite crafts but not recognized as art. When rugs or American women's quilts began to be exhibited in art museums, they were often detached from their cultural background, with no mention of their functions and origins. Quilts were treated as merely abstract shapes and patterns, linked up to the then-current trend in 'high art' in galleries and museums (this is much like the elevation of Australian Aborigine dot paintings or African sculpture to abstract art, which I discussed in Chapter 4). And when quilts, pots, blankets, and rugs got into art museums, they often were described as being made by 'anonymous' or 'nameless masters'—even when it was known (or could have been discovered) who produced the work! This suggests that women's art flows naturally, without struggle or training, and is too naïve to exemplify an artistic tradition or style. But tradition plays a significant role in these 'feminine' arts, and various types of quilts had specific meanings and roles in women's lives. Women quilt-makers often signed and dated their quilts. The Guerrilla Girls make this clear by discussing the African-American quilt-maker Harriet Powers, whose works now hang in the Smithsonian and the Boston Museum of Fine Arts.

A feminine essence?

Some women artists have been recognized, like Georgia O'Keeffe. But the Guerrilla Girls complain that this work is not treated on a par with men's: it is always downplayed by being labelled 'female.' In fact, Alfred Stieglitz, the gallery owner who later became O'Keeffe's husband, exclaimed when he first saw her paintings, 'At last! Finally a woman on canvas!' O'Keeffe always pooh-poohed the idea that her works were somehow 'feminine', but many viewers share Stieglitz's gut reaction that they express qualities of female experience. Flowers are sexual organs, and O'Keeffe's large flower paintings often depict immense and engorged stamens and pistils, delighting in the petals' deep folds and plush textures. They do evoke (female) human genitalia in erotic ways (see Plate V).

Judy Chicago, on the other hand, deliberately gave a sexual connotation to flower imagery on plates of *The Dinner Party*. She did not just hint at but really depicted female genitalia. Chicago sought a female representation of intimacies of the female body to counteract the mostly male depictions of women in pornography and high art. *The Dinner Party* celebrated female bodily experiences by linking visual representations to texts

that conveyed women's power and achievement rather than passivity and availability.

But since 1979 when *The Dinner Party* was first exhibited, many writers, including feminists, have criticized it as either vulgar or too political, or else as too 'essentialist'. Some critics argue that art that focuses so much on anatomy and sexual embodiment ignores differences due to women's social class, race, and sexual orientation. *The Dinner Party* has been called simplistic and reductive—as if the achievements of women it is meant to celebrate are cancelled out by the omnipresent and repeated vaginal imagery of each place setting.

A more recent strategy that some feminist artists employ, in contrast to Chicago's reductive and biological approach, is deconstruction. They 'deconstruct' the cultural constructs of femininity by proposing that femininity is not real, but is the artificial product of images, cultural expectations, and ingrained behaviours, such as ways of dressing, walking, or using makeup.

Many deconstructive feminists have worked in film and photography. An example of this approach, which differs radically from Chicago's, is the photography of Cindy Sherman. Sherman became known in the 1980s for the *Untitled Film Stills* series in which she depicted herself in a variety of poses and situations. A

19 Cindy Sherman's *Untitled Film Still #14*, 1978, multiplies images of the artist as if to convey that her essence can't be pinned down.

chameleon, the young and bland-looking artist was unrecognizable from one scene to the next, as she changed her makeup, hairstyle, pose, and facial expressions. By evoking scenes from old Hollywood melodramas and thrillers, the images conveyed vague feelings of tension and threat. The 'real' woman behind the scenes remained hidden and could not be ferreted out. Sherman had no 'essence' at all—let alone one rooted in biology or genitals. Instead, in this work she is a construct of the camera, elusive, a mystery. But the images do not convey a negative message. Rather, they celebrate the female artist's ability to turn the tables on the men who have typically been empowered to show women and make them behave in socially approved ways.

Sex and significance

Let me ask again, in looking at an artwork, is the gender or sexual orientation of the artist important? My inclination is to waffle: at times yes, and at other times no. Let me clarify this ambiguous answer as I sum things up.

First, the fact is that gender *has* mattered in the history of art. Renoir allegedly and notoriously said, 'I paint with my prick'. Museum walls are dominated by

female and not male nudes, done by male and not female painters, just as the Guerrilla Girls have said. Male artists have often seen women as not only sexual objects but simultaneously as their inspirations and muses. (Or, like Leonardo and Michelangelo, they displayed at least some homoerotic interest in idealized male nudes.) And there have been significant restrictions on women's ability to produce art and have their work recognized. These range from the very overt (such as Rosa Bonheur's need to petition to wear trousers to visit the horses she wanted to paint) to the more covert (such as male critics' comments on O'Keeffe's flower paintings). Gender matters if you are looking deeply into questions about who got into the canon of art or music history and why, with what sorts of work. But it does not seem right to say that Bonheur's powerful horses are in any way 'feminine' or that, because Fanny Hensel could not get symphonies produced, her chamber music is somehow 'female' in its very nature.

This leads to my second point, that gender can matter in art history (along with sexual preference) if it reflects a deep personal concern that the artist wants to express in a work. When an artist has *any* thought or feeling that shows up in a work, it is usually important to know about that to understand the work better. The artist might have a political aim (as Goya did in some of

his paintings), or may wish to express a religious concern (like Serrano in *Piss Christ*), or feelings about death and mortality (like Damien Hirst in his shark piece). Religion, sexuality, and politics have affected the output, imagery, and styles of artists over the centuries, from ancient Athens to medieval Chartres, and on up through the Renaissance and beyond. Given that feminism and gay liberation were important political movements, recent art work unsurprisingly made gender and sexual orientation important. Such work continues a long-established tradition. It would be wrong-headed to overlook gender and sexuality in commenting on Mapplethorpe's work or Judy Chicago's *Dinner Party*; but good art is not exhausted by one theme. An erotic dimension is consistent with lofty religious or mythological themes (as in Botticelli and Titian); and a political aim can be shown in work that is formally experimental and striking (like Rivera's murals or Picasso's *Guernica*).

The harder cases are about art where the role of gender in relation to meaning and expressive aims is unclear, but some critics claim it is relevant. It seems surprising to think that Schubert's being gay (if he was) affected the meaning of his music. Some people more readily recognize, though, that Tchaikovsky's *Pathètique Symphony* expresses his tortured emotions about being a

closeted gay man. And the new musicologists do believe they can detect stylistic and musical differences between the 'macho' Beethoven and the more 'expressive and lyrical' Schubert.

As I implied above, there are flowers and then there are flowers (or to rephrase Gertrude Stein, sometimes a rose is *not* a rose). In order to interpret artworks, we must look beyond gender and sexual preference to the broader context that gives any art its meaning. For Rachel Ruysch in Holland in the 1740s, flower painting was part of the tradition of the *vanitas* image. For Judy Chicago in San Francisco in the 1970s, flower imagery alluded to free female sexuality and a feminist stance about values and histories. O'Keeffe's flowers seemed to revel in a woman's independent awareness of her physical and spiritual self. But this is not *all* that her work is about; O'Keeffe painted many subjects besides flowers; and even her flower images are also 'about' form, light, composition, and abstraction—just as female nudes by Picasso and De Kooning are 'about' cubism or expressionism, as well as libido. Attention to sexuality may be relevant, but ultimately we need to think more deeply about how to *interpret* art. That will be our topic for Chapter 6.

Cognition, creation, comprehension

Getting at meaning

Gender and sexual preference—together with nationality, ethnicity, politics, and religion—all seem to have some impact on the meaning of art. People have debated for centuries about the meaning of some works of art—for example, the *Mona Lisa*'s smile. Does art bear a message in the way language does? What must we know to clarify an artwork's meaning: external facts about artists' lives, or internal facts about how their works were made? Can't we just look at an artwork for enjoyment? I will take up questions about meaning and interpretation in this chapter, introducing and considering two main theories of art, the expression theory and the cognitive theory.

In Chapter 3, we reviewed John Dewey's claim that art was the best way to understand a culture. He thought you needed to learn how to understand the

'language' of art from a different society, but then it offers up a meaning. Art's language isn't literal—Dewey said that understanding art is like understanding another person. You may know how to interpret your beloved's smile, but can you summarize it in a sentence? You understand its meaning because of your knowledge; and art too requires knowledge of context and culture. Buddhist art can't have a Christian meaning, nor would *Brillo Box* make sense to people in ancient Athens. Australian Aboriginal dot paintings might resemble modern art canvases from Paris and New York, but the artists' aims and intentions are very different.

Both the expression and the cognitive theories of art hold that art *communicates*: it can communicate feelings and emotions, or thoughts and ideas. Interpretation is important because it helps explain how art does this. Art acquires meaning in part from its context. For Dewey, this is the communicative context of a culture. For Arthur Danto, it is the more specialized context of the artworld. An artist like Warhol creates work within a concrete situation which enables him to endow it with a certain meaning. When Warhol exhibited his *Brillo Box*, it meant (in part), 'This, too, can be art'—unlike the ordinary soap-pad boxes in a grocery store.

Sometimes critics advance interpretations that artists

themselves reject. Feminist critics, for example, think that nudes done by great artists like Renoir, Picasso, and de Kooning reflect ways men have often seen women as their muses and/or sexual property. What legitimizes an interpretation of a work, if the artist disagrees?

I would describe interpretations as explanations of how a work functions to communicate thoughts, emotions, and ideas. A good interpretation must be grounded in reasons and evidence, and should provide a rich, complex, and illuminating way to comprehend a work of art. Sometimes an interpretation can even transform an experience of art from repugnance to appreciation and understanding. It will help if we look at an example.

Interpretation: a case study

Although no one interpretation is 'true' in an absolute sense, some interpretations of art seem better than others. Let's consider an artist whose work inspires interpretive disputes, the prominent Irish–English expressionist painter, Francis Bacon (1909–1992). Bacon painted people who look tortured and despairing. His figures are distorted, their mouths screaming—observers said Bacon made humans look like slabs of

raw meat. One gets this initial impression just from looking at the paintings.

For example, consider Bacon's monumental *Triptych* of 1973 (see Plate VI). In the centre panel a male figure sits on a toilet, while beneath him oozes a bat-shaped puddle of ominous blackness. The images look dark and disturbing; they almost reek of death. But here, as in other canvases, formal features counteract the visceral emotional impact. The triptych format itself recalls religious icons and altarpieces. Pain is offset by the almost static composition and use of deep, unusual colours. Reviewer Mary Abbe comments on these tensions in Bacon's work:

> [F]or all their nastiness and brutality, there is something undeniably beautiful, even serene in these paintings. . . . Bacon . . . achieved a kind of lyricism that makes even his most horrific subjects compatible with the drawing rooms in which many of them hung. Backgrounds of boudoir pink, persimmon, lilac and aqua combine with the calligraphic grace of his fleshy figures in images of stylized elegance.

Critics assemble interpretations using diverse approaches. Some people downplay emotion and pursuit of meaning and focus only on compositional beauty. The formalist critic David Sylvester, an early defender, emphasized Bacon's use of abstraction in the

face of many objections to the canvases' harrowing contents. Especially when first exhibited, Bacon's work (like Serrano's *Piss Christ*) overwhelmed viewers; so it was necessary to point out how these paintings really did manifest *form*. Sylvester went too far, though, by de-emphasizing the visceral emotional qualities of Bacon's work. Sylvester saw Bacon's 'screaming bloody mouths ... simply as harmless studies in pink, white, and red'. I would call Sylvester's early criticisms inadequate, then, as an interpretation of Bacon.

To correct Sylvester's overly formalist approach, some critics go to the opposite extreme and provide a psychobiographical interpretation. Because Francis Bacon had a horrendous relationship with his father, who whipped and kicked him out as a child for his homosexuality, he is ripe for Freudian theorizing. Perhaps other aspects of Bacon's life are reflected in his art. His horrific imagery may reflect his experiences in cleaning corpses out of bombed-out buildings in London during World War II. Bacon led an unusually wild life of heavy drinking, gambling, and constant S&M sexual escapades.

Bacon himself rejected readings of his work in terms of either his personal obsessions or the supposed angst of the twentieth century. He claimed his work was only about *painting*. He was obsessed with other painters,

especially Velázquez, Picasso, and Van Gogh. Since Bacon recreated some of their famous works in his own distinctive style, it seems that his works are indeed about how to paint in a new and different era. Still, I don't quite believe Bacon completely, nor would I rule out his biography altogether; it somehow provides background context for the raw urgency and harrowing content of the paintings.

Another critic, John Russell, helps us see that the blurred figures in Bacon's works had sources in the animal movement studies done by photographer Eadweard Muybridge. The earlier artist's time-lapse photos gave rise to Bacon's images of running dogs and wrestling men. Russell explains that Bacon sought to blur the boundaries between representation and abstraction. In a sort of competition with abstract artists like Jackson Pollock, he used photography in a new way—almost as if denying the upstart medium's challenge to painting as *the* medium of realistic depiction.

Critical disagreement about the meaning of Bacon's work is typical of debates in the artworld. I do not think that such conflicts are insoluble. Critics help us see more in the artist's work and understand it better. Interpretations are superior if they explain more aspects of the artist's work. The best interpretations pay attention both to Bacon's formal style *and* to his

content. In interpreting Bacon, I would not 'reduce' his art to his biography, but some facts about his life seem to reveal things about how he painted people. For example, biographers explain that the image we have been considering, *Triptych* of 1973, was 'about' a particular death: it was both exorcism and commemoration of the suicide of Bacon's former lover, George Dyer, who died in their hotel bathroom in Paris just before the opening of a major exhibit of Bacon's paintings. Knowing this, one looks at the work differently—it still seems horrifying (perhaps more so), but is an even more impressive achievement of artistic transformation. But content is not everything, either. Bacon's forms, compositions, and artistic sources are also relevant.

My case study of how to proceed in interpreting Bacon illustrates the cognitive theory of art I favour: artwork like Bacon's communicates complex thoughts, so it is similar to a language. But another popular account of art may seem to apply to Bacon, the expression theory, which holds that art communicates emotions, so is like laughing or screaming. Bacon certainly seems to express feelings; indeed, some of his paintings themselves (and not just the people in them) seem to scream. Let's take a closer look, then, at the expression theory of art.

Expression theory: Tolstoy

As we might expect, the expression theory holds that art communicates something in the realm of feelings and emotions. Leo Tolstoy, the Russian novelist (1828–1910), advocated this view in his famous essay, 'What is Art?'. Tolstoy believed an artist's chief job is to express and communicate emotions to an audience:

> To evoke in oneself a feeling one has once experienced and having evoked it in oneself then by means of movements, lines, colours, sounds, or forms expressed in words, so to transmit this feeling that others experience the same feeling—this is the activity of art. . . .

The expression theory works well for certain artists or art styles, notably Abstract Expressionism, which seems to be all about the expression of feelings. Nudes by de Kooning, for example, seem to express the artist's ambivalent and complex feelings about women, as both alluring yet also frightening and devouring. Mark Rothko's dark paintings seem to express depressed and sombre emotions. And Bacon's paintings express angst or despair. The expression theory also seems to work well for music. Bach's music expresses his Christian spirituality—as does Wagner's music in *Parsifal.*

Expression occurs in modern music as well: the Polish composer Penderecki's *Threnody for the Victims of Hiroshima* opens with a sequence of violin shrieks in blocks of high-pitched sound, which seem to express a post-nuclear scream of agony.

But, criticizing Tolstoy, some theorists point out that an artist need not *have* the feeling in question in order to express it. If Bacon took weeks or even months to complete his *Triptych* of 1973, it seems unlikely he was himself 'feeling' one emotion the entire time. Penderecki, similarly, did not necessarily create his work when he was full of feelings about a bombed-out city (let alone the feelings of the bomb's victims). He wrote expressive music with a different title, and only renamed the piece 'Hiroshima' later. When music or art expresses something, perhaps this has more to do with how it is arranged than with what the artist was feeling on a given day. The expressiveness is in the *work*, not the *artist*. This expressiveness is what makes Penderecki's music function effectively in very different contexts—for example, in the score of Stanley Kubrick's spooky movie, *The Shining*.

Freud on sex and sublimation

Another theorist who saw art as expression was the pioneering psychoanalyst, Sigmund Freud. Of course, a key difference between Freud and Tolstoy was that Freud believed art expresses *unconscious* feelings—ones the artist might not even admit to having. Freud described certain biologically based desires—both conscious and unconscious—that allegedly develop in all humans along predictable paths. His account of the mind and of expression in the arts has been very influential. Freud saw art as a form of 'sublimation', a gratification that substitutes for the actual satisfaction of our biologically given desires (such as the desire for oral or genital pleasure). Freud explained:

> [The artist] is urged on by instinctual needs . . .; he longs to attain to honour, power, riches, fame, and the love of women; but he lacks the means of achieving these gratifications. So, like any other with an unsatisfied longing, he turns away from reality and transfers all his interest, and all his libido, on to the creation of his wishes in the life of phantasy, from which the way might readily lead to neurosis.

The artist avoids neurosis by elaborating fantasies or day-dreams, providing a general source of pleasure for other people as well.

Sublimation sounds like a negative concept—since we sublimate when we can't get the 'real thing'. But Freud held that sublimation was of great value, in part because it led humans to produce marvellous things like art and science. Also, we just cannot gratify every desire that arises, because to do so would destroy civilization by breaking down its necessary restrictions. Freud held that art expresses unconscious and fairly universal desires. Freud studied biographies in order to try to grasp artists' personal histories, while emphasizing artworks' relationship to their creator's unconscious feelings and desires.

Since Freud, theorists have often found psychoanalytic interpretations insightful. A psychoanalyst might explain de Kooning's frightening huge female nudes in terms of 'castration anxiety'. Other psychoanalytic studies are well known, including Freud's own account of Hamlet's 'Oedipus complex'. Freud also wrote about the *Moses* of Michelangelo, some of the paintings of Leonardo, and the 'uncanny' stories of E. T. A. Hoffmann.

Freud's discussion of Leonardo da Vinci's work focuses on a childhood memory the artist had of being visited in his cradle by a bird of prey. Confused by a mistranslation of Leonardo's Italian word into German, Freud took this bird to be a vulture; he felt we can see

the image of this vulture in a famous Leonardo painting of the Virgin with child and her mother. Freud goes on to analyse Leonardo's well-known imagery, like the famous smile of the *Mona Lisa* and his beautiful images of children's heads. Freud claimed these works refer back to the artist's childhood:

> If the beautiful children's heads were reproductions of his own person as it was in his childhood, then the smiling women are nothing other than repetitions of his mother Caterina, and we begin to suspect the possibility that it was his mother who possessed the mysterious smile—the smile that he had lost and that fascinated him so much when he found it again in the Florentine lady.

Not every expression theory requires accepting the assumptions of psychoanalysis. Freud's theory does indeed ask a lot, with its commitment to the existence of unconscious desires, a 'libido' (which develops in regular stages), the logistics of sublimation, and so on. I next want to describe a group of expression theorists who focused less on biography than on art itself, holding that art is capable of expressing more conscious ideas and beliefs.

Expressing ideas

A chief problem with expression theory, whether Tolstoy's or Freud's, is that it seems too limiting to insist that art can only express emotions (whether conscious or unconscious). Ancient tragedies and medieval cathedrals, like Zen gardens and the paintings of O'Keeffe or Bacon, express more than mere emotions: belief systems, views of the cosmos and its order, ideas about abstraction in art, and so on. One way to put this objection is to say that art can express or communicate not just feelings but also *ideas.*

This sort of revised or enhanced version of expression theory was developed by a variety of people, including Benedetto Croce (1866–1952), R. G. Collingwood (1889–1943), and Suzanne Langer (1895–1985). Though they disagreed about details, all three endorsed the view that art can express or convey ideas as well as feelings. Langer argued that there is actually not such a sharp line between expressing ideas and emotions:

> The word 'feeling' must be taken here in its broadest sense, meaning everything that can be felt, from physical sensation, pain and comfort, excitement and repose, to the most complex emotions, intellectual ten-

sions, or the steady feeling-tones of a conscious human life.

Artists are often admired because they can express ideas in ways that are original, apt, and unique to a particular medium. Langer explains:

> Sometimes our comprehension of a total experience is mediated by a metaphorical symbol because the experience is new, and language has words and phrases only for familiar notions. . . . But the symbolic presentation of subjective reality for contemplation is not only tentatively beyond the words we have; it is impossible in the essential frame of language.

Whereas Tolstoy thought the artist had a feeling that 'boiled out' into a work, Collingwood argued that making art comes, in a sense, *before* having a feeling. To express the feeling in art is part of understanding the feeling. He explained, 'Until a man has expressed his emotion, he does not yet know what emotion it is. The act of expressing it is therefore an exploration of his own emotions. He is trying to find out what these emotions are.' When viewers follow the artist's efforts, we recreate the process of self-discovery, so we too become artists: 'As Coleridge puts it, we know a man for a poet by the fact that he makes us poets'.

Foucault and Las Meninas

Expression theories often emphasize the individual artist's desires and emotions. But the role of the artist is downplayed by more recent proponents of the so-called 'death of the author' view, like French theorists Roland Barthes and Michel Foucault. Foucault (1926–1984) wrote his influential article, 'What is an Author?', in 1969. He argued that we use the notion of the author so as to identify things as 'works' which somehow have importance and 'regulate discourse'. Foucault criticized what he called 'the author-function'—he thought that we become too locked into the search for correct interpretations by deferring to 'what the author intended'. What is his own alternative explanation of meaning?

An illustration of Foucault's views comes in the opening chapter of his 1966 book, *Les Mots et Les Choses* (*The Order of Things*), where he discussed a very famous painting by Velázquez, *Las Meninas* (*The Maids of Honour*). Velázquez's huge masterpiece, painted in 1656, is a portrait of the little princess or Infanta of Spain with her maids. They are shown in a large room, surrounded by other characters, including the artist himself, who stands at his easel. We also notice a dog, windows, a doorway, paintings on the walls, and a mirror in the far

20 In Diego Velázquez's *Las Meninas*, 1656, the artist depicts himself creating a painting; is it this very painting?

background. The mirror reflects a dim image of the Infanta's parents (and the artist's patrons), the King and Queen of Spain.

Velázquez's painting presents a kind of paradox or conundrum to viewers. It is hard to interpret because of visual puzzles it raises. For example, the artist in it is working on a huge painting—one, incidentally, with roughly the proportions of *this* painting—but we cannot see it. If we could, would it be this very painting? And further, what is the source of the image in the mirror of the king and queen? For them to be reflected seems to imply their presence before the painting itself—but this is where we ourselves stand when we gaze upon it!

Foucault narrated an engaging tour through this painting, which he called 'a representation of representation'. The work depicts many modes of visual reality, including pictures, doorways, people, and even light itself. Foucault interpreted the work not in terms of what was meant by its 'author', the artist, but as exemplifying the view of its time period. Foucault labelled this sort of cultural viewpoint an 'episteme'. *Las Meninas* typifies the early modern episteme, which placed a new focus on self-consciousness and on the perceiver's role in viewing the world. The ironic thing is, according to Foucault, that in this episteme, the subject cannot truly perceive himself. We viewers seem to

be displaced by the king and queen, who are the painting's owners and commissioners, hence its 'proper' viewers. And we cannot see or 'own' the resulting painting, because its back is turned to us.

Foucault's interpretation of *Las Meninas* has been challenged by scholars who think he was mistaken about details of the painter's use of perspective. They debate, as well, who or what is shown in the mirror. Perhaps the mirror image reflects not a king and queen who are hypothetical viewers from where we are, outside the painting, but rather their images within the canvas Velázquez is working on in the picture—since its back is to us, we cannot be sure.

A key point to take away from this brief overview is that, even though Foucault rejected the claim that we should interpret art by looking into the artist's mind, he assumed that artworks *do* have meanings. Meaning is a matter not so much of artists' desires and thoughts, as of the era in which they live and work. Artists share thematic concerns in a given episteme with other intellectuals, including philosophers and scientists. By focusing on the social and historical context of artists, Foucault's view turns out to resemble those of Dewey and Danto; all seem to agree that art has a meaning grounded in both culture in general and in the specifics of a historical context.

Cognitive theories: pragmatism

John Dewey, whose views I keep referring to in this book, is known as a leading advocate of the philosophical approach of pragmatism, a major American contribution to philosophy. Pragmatists before Dewey, like William James and Charles Sanders Peirce, developed a new theory of truth that emphasized usefulness or even 'cash value' rather than abstract ideals, such as a correspondence with 'Reality'. The pragmatists defined knowledge as more than a matter of espousing propositions and truths. They held there can be 'knowledge how' and emotional knowledge, for example.

Dewey defined knowledge as 'instrumental' and explained this by saying that it 'is instrumental to the enrichment of immediate experience through the control over action that it exercises'. I classify Dewey's approach to art as a cognitive theory because he applied his pragmatist account of knowledge to the analysis of art in his book, *Art as Experience*. He emphasized art's role in enabling people to perceive, manipulate, or otherwise grapple with reality. Art has a function in our lives and should not be remote and esoteric. Art is not just something to store on a shelf, but something people use to enrich their world and their perceptions.

Dewey argued that art can be a source of knowledge just as much as science. Art conveys knowledge of how to perceive the world around us, something not readily reducible to a series of propositions: '[T]he medium of expression in art is neither objective nor subjective. It is the matter of a new experience in which subjective and objective have so cooperated that neither has any longer an existence by itself'. What we learn from art depends upon our aims, situations, and purposes, and it is always 'active' or relevant to a lived experience.

A more recent philosopher who developed the pragmatist view of art was the late Nelson Goodman, a Harvard professor whose important book, *Languages of Art*, was published in 1968. Like Dewey, Goodman championed art's role in our lived experience. Goodman too did not restrict the definition of knowledge or cognition to a mere dry list of true statements. He wrote:

> What we know through art is felt in our bones and nerves and muscles as well as grasped by our minds . . . [A]ll the sensitivity and responsiveness of the organism participates in the invention and interpretation of symbols.

Languages of Art developed Dewey's view of art as a kind of language, as Goodman analysed the complex

structures of symbols that achieve meaning and refer-
ence in art. Different arts do this differently: music
has a score whereas dance does not; different nota-
tion systems apply to art forms like poetry and music;
and painting or sculpture function to communicate in
still other ways. But each form of art enlarges upon
our understanding of a world. Goodman held that art
can fulfil the same criteria that make scientific
hypotheses successful: clarity, elegance, and above all
'rightness of rendering'. In Goodman's pragmatist
view, scientific theories and artworks create worlds
that seem right in relation to our needs and habits
(or what can become our habits). If they do this, they
help us, as Goodman puts it at the very conclusion of
Languages of Art, 'in the creation and comprehension
of our worlds'.

Goodman did not talk much about what individual
artists actually say in their works. There is very little in
his book on the topic of interpretation. An important
influence in Goodman's book was the perceptual
psychology of his day. He was concerned with how the
various arts achieve a cognitive value by altering our
modes of perceiving and interacting with the world
around us. In this regard he is, despite many surface
differences of style and aims, again a true heir of Dewey,
because both men see art as something that we humans

employ to engage with our environment—by transforming our perceptions, art energizes us.

Mind, brain, and art

Studies of perception and the mind have grown and changed radically since the era of Freud, Dewey, and even Goodman. The new field of cognitive science—an exciting intersection among psychology, robotics, neuroscience, philosophy, and artificial intelligence—has major consequences for our understanding of the creation, interpretation, and appreciation of artworks. Neuroscientists have used MRIs to study how the brain activities of artists differ from those of non-artists in performing tasks like drawing portraits or abstract designs. New scientific studies explain how visual perspective works in painting, or why we regard certain patterns and colours as beautiful. If new studies of memory and the brain disprove Freud's fundamental hypotheses about the mechanism of repression, then Freud's theory of libido becomes less plausible, and psychoanalysis is undermined as a theory of art. Recent work in perceptual psychology has been taken to undermine some key aspects of Goodman's theory about which images count as 'realistic' and why.

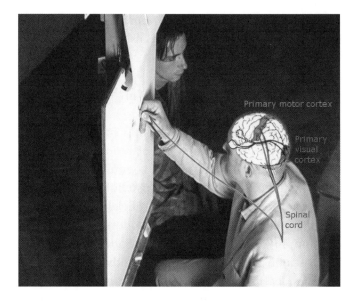

21 Scientists Chris Miall and John Tchalenko studied the brain of artist Humphrey Ocean doing a portrait sketch (1998); they also did MRIs of his brain at work.

The cognitive revolution is being applied within film theory to explain how we comprehend the visual depictions of people, places, and narratives in movies. Researchers are conducting empirical studies to explore how humans interpret and remember musical structures. In her book *Language, Music, and Mind*, Diana Raffman discusses research in music perception that explains certain aesthetic phenomena such as the so-called 'ineffability' of music. Semir Zeki supports Alexander Calder's claim that secondary colours would 'confuse' the clarity of his mobiles in neurological terms by studying how our brain cells signal the perception of motion. Zeki believes 'that artists are in some sense neurologists, studying the brain with techniques that are unique to them, but studying unknowingly the brain and its organization nevertheless'.

Perhaps not surprisingly, some people worry that a scientific explanation of art will be reductive. The sceptics might shake their heads over a recent discussion about art and beauty in *The Journal of Consciousness Studies*, summer 1999, where V. S. Ramachandran, a prominent professor of neuroscience and psychology, attempted to articulate eight criteria or conditions of artistic experience:

We present a theory of human artistic experience and

the neural mechanisms that mediate it. Any theory of art (or, indeed, any aspect of human nature) has to ideally have three components. (a) The logic of art: whether there are universal rules or principles; (b) The evolutionary rationale: why did these rules evolve and why do they have the form that they do; (c) What is the brain circuitry involved? Our paper begins with a quest for artistic universals and proposes a list of 'Eight laws of artistic experience'—a set of heuristics that artists either consciously or unconsciously deploy to optimally titillate the visual areas of the brain.

Ramachandran's claim to articulate *the* principles of art seems grandiose and subject to challenge. (To be fair, the journal did publish criticisms from scientists, artists, and art historians.) The scientist assumes that all art aims at beauty (he even slips into speaking about what is 'pretty'); but we know from Chapter 1 (on blood) that this is not true. Further, his choice of the verb 'titillate' in the quotation above seems all too apt, because many of the article's illustrations are depictions of erotic nude females. The article suggests that 'our' interest in their beauty derives from universal evolutionary imperatives—a point that cries out for some Guerrilla Girls intervention!

Although it is easy to criticize, Ramachandran's article does present intriguing proposals, for example,

concerning the importance of the 'peak shift effect', a phenomenon well known in psychological studies, where a subject trained to recognize and respond to a phenomenon will respond even more strongly to an exaggerated instance of it. This might explain the success of caricatures, or of art that shows something recognizable with an extreme and shifted shape or colour system. In the end, since art inevitably depends on perceptual and cognitive processes, new research into the neurological bases for art is interesting and suggestive.

Interpretation as explanation

Let me sum up. On the sorts of art theory considered in this chapter, expression theory and cognitive theory, art plays a key role in human communication. This makes interpretation an important task because it attempts to articulate what an artist or artwork communicates. The expression theory focuses on what an artist is expressing in a work. Some proponents of this view, like Tolstoy and Freud, emphasized that what is expressed are feelings and desires (conscious or unconscious). Other thinkers (Croce, Collingwood, Langer) argued that art helps artists express their own emotions in complex

ways that were linked to expressing ideas. This approach to expression theory comes closer to the cognitive theory of art, which holds that art helps provide knowledge. Dewey's pragmatist view of art emphasized art as a form of insightful cognition, employing a language-like structure. Of course, there are also disagreements about how audiences 'receive' the feelings or thoughts of an artist: by direct transmission (Tolstoy), by recognizing a common fantasy (Freud), by sharing an episteme (Foucault), or by a process of language-like interpretation (Goodman).

Many people who have theorized about how to interpret art, whether using expression or cognitive theories, share the fundamental idea that art is a branch of meaningful human activity through which people with minds can communicate. To explain this, art theorists draw on philosophy, and also on the human sciences, such as anthropology, sociology, and psychology, especially perceptual psychology. Freud's art theory developed out of his own new account of the mind. Foucault embraced a less individualized and biological, and more social-historical, approach to constructing his account of the mind. Dewey thought art was organically based, but also culturally situated. Goodman turned for inspiration and insight to the top perceptual psychologists of his day. All these art

theorists might be intrigued by new developments in cognitive science.

I agree with Dewey that art is a cognitive enterprise. That is, artists like Francis Bacon express thoughts and ideas in a way that can be communicated to audiences, enriching our experiences. Artists do this in a context, and their 'thoughts' serve some specific needs within that context. Artists now function within the context of what Danto has called the 'artworld,' a set of institutions linking them to a public within a social, historical, and economic environment. They create or transmit knowledge through recognized venues: exhibitions, performances, publications. Artists use symbols to represent and express feelings, opinions, thoughts, and ideas. Artists communicate to an audience, which in turn must interpret the artworks.

To 'interpret' is to offer a rational construal that explains the meaning of an artwork. I do not believe that there is one true account of 'the' cognitive contribution made by an artwork. But some interpretations work better than others. The most advanced interpretations are reasoned, detailed, and plausible; they reflect background knowledge and community standards of rational debate. Specialist interpretation is central to the communicative success of art, and it also plays an important role in the education and training of new

artists. Interpretations and critical analyses help explain art—not so as to tell us in the audience what to think, but to enable us to see and respond to the work better for ourselves.

Digitizing and disseminating

A democracy of images

Everyone knows what the *Mona Lisa* and Michelangelo's *David* look like—or do we? They are reproduced so often that we may feel we know them even if we have never been to Paris or Florence. Each has countless spoofs—David in boxer shorts or the *Mona Lisa* with moustache. Art reproductions are ubiquitous. We can now sit in our pyjamas while enjoying virtual tours of galleries and museums around the world via the Web and CD-ROM. We can explore genres and painters and zoom in to scrutinize details. The Louvre's Website offers spectacular 360-degree panoramas of artworks like the *Venus de Milo*. Such tours may become ever more multi-sensory by drawing on virtual reality (VR) technology, which includes things like goggles and gloves. Lighting and stage set designers,

like architects, already use this technology in their work.

It is not just visual art that has been made more widely accessible by new technologies of reproduction. Operas, plays, and ballet performances are regularly broadcast on TV, and more people know the music of Bach and Beethoven from CDs or radio than from live concerts in churches or symphony halls. If I admire the movies of the late Stanley Kubrick, I can own copies in high-resolution DVD (letterbox format of course). And the new media make possible not just new interactions with 'old' art, but entirely new kinds of art as well: multimedia performances, Web-based art, digital photography, and more.

Human experiences of art have been significantly changed in this postmodern age of the Internet, videos, CDs, advertising, postcards, and posters. But for good or ill? And how have artists responded? In this final chapter, I will consider the impact of new communications technologies on art. We will look 'back to the future' by exploring how art's past is digitally disseminated by futuristic technologies across the global village. Three theorists will be our guides: Walter Benjamin, Marshall McLuhan, and Jean Baudrillard. Their attitudes range from enthusiastic endorsement to cynical doubts.

Benjamin and tarnished auras

Perhaps the power of the painter's images or the musician's sounds is eroded in reproductions so that we miss out on something that emanates from the original. Philosopher and social critic Walter Benjamin (1892–1940) called this missing quality the 'aura' in his famous 1936 essay, 'The Work of Art in the Age of Mechanical Reproduction'. He concluded, surprisingly perhaps, that the loss of aura was not a bad thing. Influenced by Marxism's materialist conception of history, Benjamin celebrated the newer, more democratic forms of art that photography facilitates. He believed that mass reproduction contributed to human emancipation by promoting new modes of critical perception.

The aura of older artworks stemmed from their special power in religious cults and their unique situation in time and space. Recall that we have encountered numerous cases—Australian Aborigine dot paintings, Chartres' windows, African nail fetish sculptures, and ancient Greek tragedies—where art is closely tied to communal ceremony and religious ritual. Special and unique objects were somehow decorated, used, and treasured as part of these ceremonies and acquired a precious, sacred 'aura'. But art evolved over many centuries as humans created modes of mechanical

reproduction, like engraving, to share and disseminate art. And in particular the invention of photography made the 'original' less relevant. Photography challenges the uniqueness of the work of art. However, Benjamin thought something *good* happens when auras are banished. Cinema, Benjamin's main example of the new media, supposedly enhances sense perception through techniques like slow motion and close-ups. Whereas other theorists of his time denounced cinema as a crude mass art form ruled by commercialism and purveying the political agenda of a nation (especially in the fascist era), Benjamin compared features of cinema to the aims and effects of avant-garde art, and endorsed them as potentially anti-fascist and pro-democratic.

Montage in cinema, or the use of quick cuts and rapid editing, was supposedly a shock to the viewer's normal perceptual patterns and rhythms. Benjamin thought that it broadened human perceptual power in ways sought by the Surrealist filmmakers like Dali and Buñuel. Benjamin also praised 'distance' in cinematic acting. Because audiences could recognize a star on screen through close-ups and prior knowledge, he thought people would not become as absorbed in a movie's false reality as in that of a play on stage. Benjamin praised this distance effect of cinematic acting and compared it to the avant-garde 'alienation effect' of

Bertolt Brecht's theatre. In Brecht's *Mother Courage* the actors speak directly to the audience, who are meant to realize they are watching a play, reacting thoughtfully instead of seeking emotional identification and escapist entertainment.

Benjamin argued that even ordinary viewers of popular Chaplin movies can achieve sophisticated critical awareness. By comparison, the avant-garde works of Picasso or Surrealism put viewers off, hinting that they are too stupid to understand why such art is important. Movies are more democratic and everyone can 'get' them:

> The reactionary attitude toward a Picasso painting changes into the progressive reaction toward a Chaplin movie. . . . With regard to the screen, the critical and the receptive attitudes of the public coincide.

Absence (of mind)

It is difficult to endorse Benjamin's optimism today. True, movies are very popular, but the contrast between high and mass art has not vanished in cinema, as Benjamin predicted—remember the findings of French sociologist Bourdieu, mentioned in Chapter 4. Films by

a politically radical director like Jean-Luc Godard are not generally seen (or understood) by the viewing public. New techniques introduced by filmmakers which differ from the features Benjamin highlighted may have a distinct impact that need not be progressive. Digitization enhanced the visual realism of films like *Starship Troopers* and *The Matrix*; but it is hard to interpret these movies, with their messianic heroes, bloody gun battles, and alien exterminations, as having progressive political messages. Besides, we could question Benjamin's belief in certain values, like distance and the alienation effect. Films that encourage distance by featuring ever more cynical, and recognizable, action heroes (like *Alien Resurrection* and the *Die Hard* sequels) seem very dehumanizing. Their originals seem stronger, with compassionate protagonists who both manifest and evoke emotional engagement.

Or, consider film directors who have succeeded Chaplin in winning both popular and critical acclaim, like Alfred Hitchcock and Stanley Kubrick. Would Benjamin call their works 'progressive'? He praised Chaplin for providing the audience with a 'direct, intimate fusion of visual and emotional enjoyment with the orientation of the expert'. Hitchcock too was a brilliant film editor, but experts notice many things that regular movie audiences might not, such as the intricate shot

22 Just a few of the numerous edits in the terrifying shower sequence scene of Alfred Hitchcock's *Psycho* (1960), with Janet Leigh and Anthony Perkins.

structure of the infamous shower scene in *Psycho.* 'Hitch' also was notorious for referring to actors as 'cattle'; the alienation effect of acting in his films (if it does exist) could stem from his seemingly low view of individual human value. His social messages are ambiguous: what does it mean when at the conclusion of *The Birds* the hero, his family, and girlfriend drive off, defeated by the birds, into a land under siege?

Again, experts are impressed by Kubrick's exploration of technical possibilities, as when he filmed by candlelight in *Barry Lyndon* (1975) or employed the new Steadicam camera in *The Shining* (1980). But cinematic features praised by critics and other directors might not be recognized by audiences. Nor do Kubrick's films use an alienation effect in acting to prompt critical audience perceptions. Audiences might instead be drawn into greater identification and empathy by Kubrick's use of handsome and popular actors like Ryan O'Neal and Tom Cruise. And, as with Hitchcock, some of Kubrick's most 'political' films like *Full Metal Jacket* (1987) or *Dr Strangelove* (1964) present ambiguous messages that are hard to interpret. His film of Anthony Burgess's *A Clockwork Orange* (1971) is another example: the novel was a critique of how mind-control reins in individuality, but audiences might instead respond to the excitement of the film's early

scenes where Alex (Malcolm McDowell) rapes and murders almost at random. Even critics who praised Kubrick's final film *Eyes Wide Shut* (1999) saw it as presenting a conservative position on the values of marriage and family.

Moreover, film has not made means of production more democratic and generally accessible than artistic media of the past. Benjamin seems naïve in attributing certain values and possibilities to the *medium*, which he thought had an inherently progressive political nature— as though it is not relevant to think more about who uses and controls it: about the vast corporate complexes (like Time-Warner or Disney-ABC) that link profit-making formulaic genres to burger outlet gimmicks, 'news'-source PR, and video sales. Some of Benjamin's remarks sound very paradoxical, as when he says, 'The public is an examiner, but an absent-minded one'. An absent-minded public is dangerously close to a public with a vacant mind, or a controlled mind.

A final point to make is that the aura of major artworks from the past has *not* really disappeared, despite ever more vivid technologies of reproduction. The Louvre's CD-ROM offers a wonderful view of the *Mona Lisa*. One can almost see her very pores on the computer screen; the reproduction is brighter than the small and almost murky original, revealing more of the

23 Using the zoom tool, the viewer can zero in on the face of the *Mona Lisa* (*La Gioconda*), by Leonardo da Vinci, 1503–1505, from Le Louvre: Collections and Palace, CD-ROM, 1997.

landscape in the background. The zoom tool permits viewers to scrutinize features as the commentator lists them: her high forehead, the rising left side of her smile, the serenely folded hands. Yet people *do* still make a pilgrimage to see Leonardo's original painting in the Louvre. The feeling of awe is almost religious as international crowds file past the mysterious visage that rests, smiling, in her closed glass box. The atmosphere is one of quiet excitement and people record the momentous occasion with videos and snapshots. La Gioconda's aura is by no means a mirage, though there is something sadly ironic about visitors' trying to capture her with their own mechanical reproductions.

McLuhan's mosaics

The Canadian Marshall McLuhan (1911–1980) also believed that new technologies promote democracy and enhance human perception. Commenting on radio, television, telephones, and computers, he coined phrases like 'the medium is the message' and 'the global village' that have become universally familiar. McLuhan felt that new media are best understood and explored by artists, who are ahead of their time in grasping possibilities of new forms of thought and

connection. He referred to the artist in society as special—as a 'discarnate man' who has 'integral awareness'.

McLuhan's scholarly career began in literary criticism. He studied authors from the past along with modernists like Joyce, Eliot, and Pound, remarking how increased literacy altered oral cultures like Homeric Greece. The invention of print and books prompted many social changes, fostering individualism, linear thinking, privacy, repression of thought and feeling, detachment, specialization, and even modern militarization (written orders could be disseminated rapidly to an army). But the newer media, McLuhan thought, will restore aspects of right-brain functioning suppressed by literacy.

In claiming 'the medium is the message', McLuhan meant that content matters less than the structures of media; they shape human consciousness in profound ways. Whereas print media isolated detached individuals who read privately on their own, the new media promote connectedness and a new international community ('the global village') that transcends parochial political barriers. Like Benjamin, McLuhan was a fan of the new media, and he too de-emphasized the distinction between 'high' and 'mass' or common art. But where Benjamin focused on cinema, McLuhan studied electronic communications, television in particular.

McLuhan was less interested in who controlled the productive forces than in the kinds of thinking and sensory awareness facilitated by TV. New media offer an aid or 'prosthesis' that changes our senses and even our brains to promote non-linear, 'mosaic' thinking, as viewers must fill in the blanks in continuously updated inputs.

The new 'global village' with its broad participation will restore the 'primitive' human capacities that have been lost, as we return to something more like an oral culture that is communal and emphasizes hearing, touching, and facial expressions. Electronic media will restore not just right-brain capacities for connection and insight, but also our capacities for integration and imagination:

> Primitive and pre-alphabetic people . . . live in an acoustic, horizonless, boundless, olfactory space, rather than in visual space. Their graphic presentation is like an x-ray. They put in everything they know, rather than only what they see. A drawing of a man hunting seal on an ice floe will show not only what is on top of the ice, but what lies underneath as well. . . . Electric circuitry is recreating in us the multidimensional space orientation of the 'primitive'.

McLuhan meets MTV

As with Benjamin, I question McLuhan's enthusiasm for the new media. To explain, let us consider two kinds of video production: first, art by Bill Viola, and second, music videos on MTV.

Bill Viola has worked with the latest video technologies (supplied with equipment by SONY) in experiments before broad release. His work explores modes of perception through editing and installation displays. Viola creates entire atmospheres by projecting video images onto walls or across people in the gallery. But along with the new, Viola draws upon the old. Long interested in mysticism, he has travelled and studied a wide variety of world religious traditions. The result has been some unusual and fascinating exhibitions.

In his *Room for St John of the Cross*, Viola combined astonishing visual imagery with texts and readings. An entire room was filled with harrying sounds of wind and storms created through electronic static. In *Chott el-Djerid* ('A Portrait of Light and Heat', 1979), Viola captured on videotape what might seem impossible, a mirage (see Plate VII). Shimmering desert heat materialized into a vision of an oasis complete with ocean and palm trees. In *I Do Not Know What It Is I am Like*, Viola spent three weeks in wintry South Dakota, taping

extended scenes of a herd of bison. Their ponderous stillness became a mirror image of the silence of the desert, as the artist showed their grazing on the prairie as a form of meditation.

Viola is influenced by the Persian mystic Rumi, who wrote back in 1273: 'New organs of perception come into being as a result of necessity—therefore, increase your necessity so that you may increase your perception.' For Viola, a technology like video is not an end in itself. He contradicts McLuhan's view that the medium has inherent possibilities to alter perception, because he believes an artist must work in advance to achieve enhanced perception. Viola faults his fellow video artists by saying that 'the technology is far ahead of the people using it'. It is also striking that the mystical writers who inspire Viola used *writing* to express their non-linear thinking and desire to abandon logic—contrary to McLuhan's picture of how writing restricts thought.

Viola's meditative videos demand patience from viewers—which probably explains why my students, from the MTV instant-stimulus generation, complained that they were 'boring'. The elaborate three-minute videos broadcast worldwide on MTV specialize in rapid cuts and montage. Music videos do not require concentration; they can be watched off-hand while doing

something else, like homework or talking on the phone with friends. They foster a distracted and fragmented attention with their multiple screens, constant cuts, and throbbing sounds. McLuhan is right in one way, of course, that MTV does not promote linear thinking. Montage often connects scenes based on feel rather than on any narrative logic. Ironically, however, many of the videos narrate minuscule dramas (typically, boy meets girl, confronts the cops, or wins fame). And as MTV has grown older than most of its viewers, it plays more rock-star biography tapes and historical pro-grammes (even nostalgic programmes featuring its own now-aged former Video Deejays). So the linear is threatening to return with a vengeance!

Most disturbing about MTV videos are their domin-ation by market forces and promotion of homogenized mono-cultural values. To be sure, there are occasional innovative 'artistic' videos by directors like Spike Jonze and Joseph Kahn, but by and large the videos are mind-numbing, with formulaic glamour shots, stage sets, pseudo-documentary street scenes, or neon animations. Stage sets littered by flashy cars and beautiful women in fur coats or bikinis make MTV the perfect vehicle for product promotion—videos alternate seamlessly with pulsing ads for shampoos, Levi's, toothpaste, or even the army, MasterCard, Cadillacs, and life insurance.

These relentless ads, coupled with the fundamental marketing aim of the videos themselves—to sell the stars, from Madonna to Eminem and Sisqo—might alarm both McLuhan and Benjamin. They could hardly believe that MTV has facilitated greater democratic participation and fostered the critical awareness of viewers gathered around the world into a genuine global village. Instead it threatens to homogenize the world into a suburban American strip mall, crowded with McDonald's and Gap stores.

Baudrillard in Disneyland

The third and final theorist of the new media whose work I want to consider, sometimes referred to as the 'high priest of postmodernism', is French philosopher, Jean Baudrillard. His ideas are often cited in critical discussions of postmodern artists. Benjamin and McLuhan were inspired by the movies and television, but Baudrillard is the theorist of the new screen, the computer monitor. He describes an audience that is not simply absent-*minded* (recall Benjamin's phrase) but *absent*: lost in its own images, absorbed into its own terminals. His is in many ways (with a nasty pun) a 'terminal' philosophy embracing millennial disillusionment.

Baudrillard, who was influenced by McLuhan, is similarly famous for slogan-like remarks and clever (but perplexing) turns of phrase. Baudrillard writes in an exaggerated style (following his philosophical fore-father Friedrich Nietzsche), so that it is hard to know at times whether he is serious or tongue-in-cheek. Key terms in Baudrillard's postmodern lexicon include simulation, the hyperreal, implosion of the masses, self-seduction, and the transparency of evil. Along with computers, he has studied television (especially news coverage), modern art and literature, and even highways, fashion, architecture, entertainment, and theme parks like Disneyland. Let us begin delving into his vocabulary.

The *hyperreal* is something 'more real than real': something fake and artificial that comes to be more definitive of the real than reality itself. Examples include high fashion (which is more beautiful than beauty), the news ('sound bites' from staged rallies determine outcomes of political contests), and Disneyland. A *simulation* is a copy or imitation that substitutes for reality. Again, the TV speech of a political candidate, something staged entirely to be seen on TV, is a good example. A cynical person might say that many weddings now exist in order for videos and photos to be made—having a 'beautiful wedding' means that it looks good in the photos and videos!

24 Postmodern theorist Jean Baudrillard meets the apt fate of being turned into an image by digital photographers MANUAL in *Simulacra* (1987).

One of Baudrillard's favourite examples is Disney-land. He explains,

> You park outside, queue up inside, and are totally abandoned at the exit. In this imaginary world the only phantasmagoria is in the inherent warmth and affection of the crowd. . . . The contrast with the absolute soli-tude of the parking lot—a veritable concentration camp—is total. . . . Disneyland is there to conceal the fact that it is the 'real' country, all of 'real' America, which is Disneyland. . . .

Baudrillard sounds like both a critic and yet a fascinated fan of Disneyland, and he exhibits similar ambivalence about other instances of the new media.

Baudrillard uses the term 'obscenity' to describe the seductive yet false immediacy of many television shows. Television reverses the Platonic relation between mimesis and reality, since the representation precedes the reality and even comes to define it. Baudrillard cites many instances, such as news coverage of soccer riots, the Gulf War, and the US incursion into Somalia. The simulation of live TV is obscene and too intimate: it becomes more real than real, or 'hyperreal.'

Since he points out problems of simulation, some of Baudrillard's writings seem not just critical but pro-nouncements of doom; he describes a millennial race to self-destruction in the dispersion of images of horror

through the new global media. Baudrillard's phrase 'the transparency of evil' suggests that old-fashioned evil, like the evil in the Bible, Greek tragedies, or even horror movies, has been reduced to nought—flattened out and copied into millions of indifferent images. As the spectacle becomes hyperreal, the depiction of violence sets the standard for reality. We can begin to see why even horrific disasters like Chernobyl or the Challenger explosion are, in Baudrillard's view, 'mere holograms or simulacra'. He would make similar comments about obsessive media coverage of the fatal crashes of Princess Diana or John F. Kennedy, Jr.

At times, however, Baudrillard sounds less cynical, and envisions options for resistance to spectacles of violence. He speaks about 'an original strategy' of 'subtle revenge' and a 'refusal of will.' Unfortunately, what he says is very sketchy. He suggests that certain aspects of the audience's enjoyment of and participation in the hyperreal are creative and even subversive. If we are 'self-seducing' ourselves in the spectacle, then we bear some responsibility. The 'self' here is crucial:

> The group connected to the video is also only its own terminal. It records itself, self-regulates itself and self-manages itself electronically. Self-ignition, self-seduction. . . . [S]elf-management will thus soon be the universal work of each one, of each group, of each

terminal. Self-seduction will become the norm of every electrified particle in networks or systems.

Cynical simulations

Baudrillard, like other postmodern critics and theorists, has been criticized as amoral and politically reactionary. If cynicism and doom are his message, then some people would prefer not to listen. But to many in the art world during the 1980s, Baudrillard's views seemed insightful—as when he wrote that 'Behind the whole convulsive movement of modern art lies a kind of iner- tia, something that can no longer transcend itself and has therefore turned in upon itself, merely repeating itself at a faster and faster rate.' He was understood as explaining that artists are reduced to empty repetitions of pre-existing imagery, an analysis that seemed to work well for many young artists of that decade. Baudrillard's message was that artists are marginal to other forces tending towards general social vacuity and despair, so that ideals of individual creativity and self-expression are no longer viable.

Ironically, this same message was used to hype a new generation of chic 'art stars' whose works sold for enormous prices. Baudrillard's theories were invoked

to praise artists like Cindy Sherman or David Salle, who recycle old, familiar imagery with a hint or aura of ominous disaster. Sherman (discussed in Chapter 5 as a deconstructive feminist artist) has created strange and elusive self-portraits, both in her early *Untitled Film Stills* and in her more recent works, which recreate ghastly versions of Old Master paintings of women. Because she draws upon pre-existing images, it is as if she herself exists as a simulation. Salle's paintings look lightweight and sketchy by comparison to a muscular modernist like Jackson Pollock. Salle too relies on numbingly familiar imagery. His canvases are pastiches, literally layered with familiar figures that seem to float in and mingle—Porky Pig, *National Geographic* 'primitives', and naked women with bodies splayed in standard porn poses.

Baudrillard seems less relevant to the artworld of the 1990s, when artists from various minority groups appeared to regain faith in the power of art to express feelings or to convey a 'message'. Black or Asian artists employed stereotypes critically and ironically to call attention to racism, and women artists like Orlan sought to reveal the damaging impact of the pervasive images of female beauty in Western culture. More recently, the hot 'Young British Artists' like Damien Hirst and the Chapman brothers have also shown faith

in the power of the image, to remind us of human mortality (as in Hirst's shark piece), or to evoke the prickly allure of sexuality. Cynicism may play a part in such works, but a cynicism linked more to the desire to shock and achieve fame, not Baudrillard's deeper cynicism about our absorption into simulation.

Cyber-art's immersive future

It would not be right to close a chapter about art in the digital era while neglecting the truest offspring of the new media. A discussion of where art is headed in the new millennium will take us away from high art—away from the London or New York City gallery and museum art scene, or the art written about in mainstream journals—out into the circuits of the society that Baudrillard, McLuhan, and Benjamin were all trying to describe. There are many examples of artwork, or at least of creative activity, developed and intrinsic to the new media, such as video games, Web-based art, hypertext literature, Japanimation 'anime' films, and more. Aspiring musicians compete with major recording studios by using MIDI and multi-track technology in conjunction with a computer in their basement or garage. By uploading files to the MP3.com Web site,

they bypass the music marketing system in the hope of making it big.

Multimedia arts productions can be ambitious, like dadaNetCircus's *Jonah and the WWWhale*, described as a 'Biblical techno-fantasy' (see Plate VIII). It revisited the comic yet moral story of Jonah using computer projection combined with live actors, singers, and dancers, along with Web-page 'sampling' inspired by the Rap music practice of sampling from recorded music. The group's dance-cum-Web productions are beamed out 'live' across the world via video-streaming.

I cannot discuss all the new artistic mediums here—and if I did, my discussion would be obsolete before this book is published. I will simply conclude by saying a few things about Web-based art and three of its key features: it is multimedia, hypertextual, and interactive.

A Web art site is more than an on-line gallery that provides static digital imagery. By using plug-ins and add-ons like Javascripts and Shockwave, video and audio samples, such sites create multimedia illusions of realism, depth, and movement through space—as with the 360-degree camera movements used to display the Louvre's courtyard and pyramid. It is only a matter of time before Web art can rival the astonishing 3-D visual realism of video-game technology. These games provide amazing renditions of three-dimensional space as the

player traverses through alien terrains, surfs on a synthetic ocean, races cars on a NASCAR track, or snowboards down a steep slope, crashing audibly into trees. Young fans of these games praise them not only for their eye-popping or jaw-dropping realism and immersive nature, but also for the creative complexity and variety of their rules and interactive options.

Some Web art is also exploiting interactivity, encouraging viewers to click on portions of the image to reveal a poem, new image, or branching pathways. Interactivity can conjoin viewers into a kind of global village. Many 'official' or established art Web sites sponsored by universities or museums demonstrate artists' experiments with the latest technologies. MoMA's Web site in New York features work by artists such as Jenny Holzer, who displays clichés on-screen and offers visitors the chance to suggest alternatives or modifications. This interactive page allows the viewer to type in an entry, which then gets displayed on a new screen, along with others previously proposed.

To illustrate the third feature of the Web, hypertext, we can consider another Web art project on the MoMA site, done by Tim Rollins with K.O.S. ('kids of survival'). Their collaboration grew out of Rollins's work as a special education teacher in New York City. Rollins and his students modernize classic literary texts

with new translations and visual imagery, then perform and discuss them with other young audiences. Their Web page for MoMA is based upon Aeschylus's *Prometheus Bound.* Its animated links permit visitors to meander paths to find translations by Thoreau or Rollins himself, hear samples in Real Audio, read about performances around the globe, and visit a bulletin board (discussing, among other topics, whether Prometheus got a raw deal from Zeus).

Re-spinning the Web

What would our theorists make of the World Wide Web? Benjamin would be impressed that the Web is a fairly democratic space for art. It has opened up the productive forces of society—at least in advanced nations of the world economy—so that almost anyone can participate. You do not have to be an artist with a degree or a gallery to create a site that can be transmitted worldwide and earn instant recognition. Fan sites for movies and books attract huge numbers of visitors and 'hits'. Benjamin would probably be disturbed, though, by the creeping onset of crass commercialism into such sites; 'free' Web servers are supported by banner ads and pop-up screens, and e-mail is plagued with 'spam'.

McLuhan would be ambivalent about the Web. It fosters 'mosaic' thinking, since hypertext is non-linear: links tempt one to mouse-clicks and lead to further paths of exploration. But the Web's potent combination of words and images in hyperlinks muddles up McLuhan's basic distinctions between the verbal and the visual, the left and the right brain. The categories of oral and literary are blurred by Tim Rollins's Web site about *Prometheus Bound.* It uses the latest techniques of animation, bulletin boards, and audio feeds, but is centred on a linear *text*—indeed, one by Aeschylus, who wrote near the dawn of the very phenomenon of literacy which McLuhan targeted for dismantling! The Web's 'global village' effects seem ambiguous, too. It draws people together and cameras enhance the sense of contact across cyberspace. Yet users remain isolated before their screens. Here we seem to have McLuhan's 'discarnate man', but does he have 'integral awareness'?

Finally, Baudrillard has long predicted the disappearance of reality and our absorption into screens in the era of cyberspace and the Web. Avatars, or alter egos that people create for on-line games or singles spaces, would no doubt confirm his beliefs about the self-seduction of the masses by simulations. We have seen above that he seems ambivalent about this idea of self-seduction. It can seem bad, as when Baudrillard

describes the world of people sitting at their computer terminals as an immersion into absence, a flattening of the full-bodied self into the screen: '[T]he excess of information upon us is a sort of electrocution. It produces a sort of continual short-circuit where the individual burns its circuits and loses its defenses.' Baudrillard sounds cynical, but there may be more positive aspects of self-seduction; that is, it makes a difference who is in control of the illusions or seductions of the Internet or the mass media. Artists and ordinary Web surfers alike will have to determine whether cyberspace truly is a new form of absence and 'transparent evil', or whether, instead, it is a place for creative, intelligent, and beneficial sensory exploration and communal connection.

Conclusion

To begin to convey the diversity of both art and art theory, I have mentioned art in this book from many eras and cultures. We have also had brief encounters with some of the primary theories in the field: ritual theory, theories of taste and beauty, imitation theory, theories that emphasize communication, whether for purposes of expression or cognition. We looked at proposals offered by distinguished ancient, modern, and postmodern philosophers. We also examined accounts offered by art critics and anthropologists. In the latter group was Richard Anderson, who held that art is 'culturally significant meaning, skillfully encoded in an affecting, sensuous medium'.

I hope that this array of accounts of art will be helpful rather than daunting. Competing theories of art have sometimes led people to throw up their hands and declare art indefinable. For example, when completing this book, I had the chance to attend a lecture by the prominent environmental artist Robert Irwin. He commented a bit cynically about the vagueness of the term 'art' that it 'has come to mean so many things that it doesn't mean anything any more'. But this didn't stop

Irwin from offering his own definition. He proposed to describe art as 'a continuous examination of our perceptual awareness and a continuous expansion of our awareness of the world around us'.

Irwin's definition encompasses many of the varied phenomena we have considered in this book. 'Expanding awareness' is a particular goal of some of the recent artists who use shock tactics, or others who focus on issues of gender, race, and sexual orientation. But it also applies to very traditional arts like Greek tragedy, Chartres Cathedral, and Native American dances. Irwin's definition emphasizes art's role in enhancing our awareness both of *ourselves* (expanding our perceptual functioning) and of the *world*. Art can do both. An African nail fetish sculpture focuses the community participants' awareness on legal agreements; a Tibetan Buddhist mandala, on spiritual matters; the garden at Versailles, on one's status in a particular hierarchical social world; Cindy Sherman's photographs, on the artifice of gender roles. And in each case the art exists in, and involves interacting with, an affecting, sensuous medium.

Art theory is not like scientific theories, such as Einstein's special theory of relativity or Darwin's theory of evolution. Physicists can predict planetary motion, and biologists aim to explain how specific traits

emerged and survived because of their adaptive value. By contrast, there do not seem to be any 'laws' of art that will predict artists' behaviours, or that explain the 'evolution' of art history by detailing what 'succeeds' in making a work beautiful or significant. (Not even the brain-based theories of cognitive science purport to do all that.) But despite these differences from science, art theory as I have described it in this book is still an explanatory enterprise: it involves the effort to organize a dizzying variety of phenomena so as to try to say what they have in common that makes them special.

That art *is* special seems indisputable. People value art and passionately pursue its creation and collection. New museums open with regularity, attracting more (and more diverse) audiences. The art market may not be as bullish now as in the 1980s, but it is still strong: Sotheby's reported total sales of $70,200,000 at its November 1999 Contemporary Art auction. Art still has the power to provoke: only now are Wagner's operas being considered for performance in Israel, and the controversial *Sensation* exhibit at the Brooklyn Museum in the fall of 1999 lived up to its name when New York Mayor Giuliani threatened to cut off the museum's funding. And as we just saw in Chapter 7, the future of art offers the fascination of both new media and new modes of access to old arts. Artists will be at the

forefront as we explore and expand our awareness, whether of radical social reforms or of the rich heritage of the past, of outer space or the inner workings of the brain. Future Goyas and Serranos will no doubt continue to find yet new ways to shock and expand our awareness, using blood and other secretions to alert us to complexities of our spiritual and political lives. And the next Botticellis and Bachs are already no doubt waiting in the wings to ravish us with the beauty of their new sights and sounds.

References

Chapter 1

The ASA panel on blood was organized by Dawn Perlmutter and included Richard Anderson. David Hume's 'The Standard of Taste' (1757) is included in *Philosophy of Art and Aesthetics from Plato to Wittgenstein*, Frank A. Tillman and Steven M. Cahn, Editors (New York: Harper & Row, 1969), pp. 115–30. Immanuel Kant, *The Critique of Judgment* (1790), trans. James Creed Meredith (Oxford: Clarendon Press, 1969). Clive Bell's 'The Aesthetic Hypothesis' and Edward Bullough's 'Psychical Distance' are also in Tillman and Cahn; the Bullough quote is from p. 403. Lucy Lippard, 'The Spirit and the Letter,' *Art in America*, 80 (4) (April 1990): 238–45; quotes are from pp. 239, 241, 244. The Goya remark is cited in Arthur Danto's 'Goya and the Spirit of Enlightenment', from *Encounters and Reflections: Art in the Historical Present* (New York: Noonday Press, Farrar Straus Giroux, 1990), pp. 253–4.

Chapter 2

Euripides, *Medea*, trans. Paul Roche (New York and London: W. W. Norton & Company, 1974), p. 66, lines 1076–9. The remark about Platonic cosmology and Chartres Cathedral is from Otto Von Simson, *The Gothic Cathedral: Origins of Gothic Architecture and the Medieval Concept of Order* (Princeton: Princeton University Press, 3rd edition, 1988), p. 26. Horace Walpole is quoted by Stephanie Ross, *What Gardens Mean* (Chicago and London:

University of Chicago Press, 1998), p. xiii. Versailles, the official Web site, is at www.chateauversailles.fr/. For Immanuel Kant's views, see *The Critique of Judgment* (Chapter 1 References), especially the 'Deduction of Pure Aesthetic Judgments' and section 51, 'The Division of the Arts'. Friedrich Nietzsche on *Parsifal*'s beauty is discussed by Ronald Hayman, *Nietzsche: A Critical Life* (New York: Penguin, 1982) p. 243; he cites a letter to Peter Gast of 21 January 1887. Nietzsche's claim that he wished he had written *Parsifal* himself is from *The Case of Wagner*, in *Basic Writings of Nietzsche*, Walter Kaufmann, editor and trans.(New York: Modern Library, 1968), p. 640. The claim Wagner 'fell before the cross' is from *Nietzsche Contra Wagner*, in *The Portable Nietzsche*, trans. Walter Kaufmann (New York: Viking Press, 1968); p. 676. Andy Warhol's slogans are in *The Philosophy of Andy Warhol: From A to B and Back Again* (New York: Harcourt, Brace, Jovanovich, 1975); and in Victor Bockris, *Warhol: The Biography* (New York: Da Capo Press, 1997). Arthur C. Danto on *Brillo Box*, *After the End of Art: Contemporary Art and the Pale of History* (Princeton: Princeton University Press, 1997), p. 125; the 'most philosophies of art' quote is from *Beyond the Brillo Box: The Visual Arts in Post-Historical Perspective* (New York: Farrar, Straus, Giroux, 1992), pp. 229–30. George Dickie, *Art and the Aesthetic* (Ithaca and London: Cornell University Press, 1974), p. 204.

Chapter 3

John Dewey, *Art as Experience* (New York: Minton, Balch & Company, 1934), pp. 334, 331, 335, 328. Clive Bell, see Chapter 1 References, pp. 422–3. Thomas McEvilley, "Doctor Lawyer Indian Chief: 'Primitivism' in 20th-Century Art: Museum of Modern Art, New York", *Artforum* 23 (November 1984): 54–61;

the quote is from p. 60. Eric Michaels, *Bad Aboriginal Art: Tradition, Media, and Technological Horizons* (St Leonards, Australia: Allen and Unwin, 1994), pp. 153, 156–7. Richard Anderson, *Calliope's Sisters: A Comparative Study of Philosophies of Art* (Englewood Cliffs, NJ: Prentice-Hall, 1990), p. 238.

Chapter 4
Emily Van Cleve, 'Here, Now, and Always', in *El Palacio* (The Museum of New Mexico Magazine), 103:1 (Summer/Fall 1998): 32–39+, p. 33. Arthur Danto, 'Museums and the Thirsting Millions', in *After the End of Art* (Chapter 2 References), pp. 175–90. Pierre Bourdieu, *Distinction: A Cultural Critique of the Judgment of Taste*, trans. Richard Nice (Cambridge, MA: Harvard University Press, 1984), pp. xiii–xiv, and p. 6. David Edward Finley, *A Standard of Excellence: Andrew W. Mellon Founds the National Gallery of Art at Washington* (City of Washington: Smithsonian Institution Press, 1973), p. 151. John Dewey, *Art as Experience* (Chapter 3 References), pp. 8, 344 (two quotes), and 27. Robert Lenzner, *The Great Getty: The Life and Loves of J. Paul Getty—Richest Man in the World* (New York: Crown Publishers, 1985), p. 180. On 'barbarians', J. Paul Getty, *As I See It: The Autobiography of J. Paul Getty* (Englewood Cliffs, NJ: Prentice-Hall, 1976), p. 280. Getty's remark on Caesar is quoted by Carol Duncan, *Civilizing Rituals: Inside Public Art Museums* (London and New York: Routledge, 1995), p. 79. Dick Price (Introduction), *Young British Art: The Saatchi Decade* (New York: Harry N. Abrams, 1999). The Corbis Web site is at www.corbis.com. The Montebello quote is from Victoria D. Alexander, *Museums and Money: The Impact of Funding on Exhibitions, Scholarship, and Management* (Bloomington and Indianapolis: Indiana University Press, 1996), p. 131. Brian

Wallis, 'Selling Nations: International Exhibitions and Cultural Diplomacy', *Museum Culture: Histories, Discourses, Spectacles*, Daniel J. Sherman and Irit Rogoff, Editors (Minneapolis: University of Minnesota Press, 1994), p. 271. 'Blue Poles' flyer, Australian National Gallery (Canberra), 1995. Barry McGee, *Hoss*, Gallery Statement, Rice University Art Gallery (Houston, Texas), October 1999. Benjamin Buchloch, 'Hans Haacke: Memory and Instrumental Reason', *Art in America*, 76(2) (February 1988): 96–109+, p. 157, n. 4.

Chapter 5

Marcia J. Citron, *Gender and the Musical Canon* (Cambridge, New York, and Melbourne: Cambridge University Press, 1993), p. 268, n. 21 (on Schubert); p. 100 (Felix Mendelssohn's letter); and p. 217 (on studying women in music). The Guerrilla Girls' comments are from their Web site, www.guerrillagirls.com; except for the passage on O'Keeffe, from *The Guerrilla Girls' Bedside Companion to the History of Western Art* (New York: Penguin Books, 1998), p. 75. Linda Nochlin, 'Why Have There Been No Great Women Artists?' in *Women, Art, and Power and Other Essays* (New York: Harper & Row, 1988), pp. 150, 176. Adelaide Alsop Robineau, *Keramic Studio*, XIV(12) (April, 1913): 247. For the canon in art, see H. W. Janson and Anthony F. Janson, *History of Art* (New York: Harry N. Abrams, 1997, 5th rev. edition); and in music, see Donald Jay Grout and Claude V. Palisca, *History of Western Music* (New York: W. W. Norton, 1996, 5th edition).

Chapter 6

The remarks on Bacon are from Mary Abbe, 'Art Institute takes Walk on Dark Side', *Minneapolis Star Tribune*, 9 April 1999; the

description of Sylvester's approach to Bacon is from Andres Mario Zervigon, 'Remaking Bacon', *Art Journal* 54 (1995): 87–93, 88. Tolstoy's 'What is Art?', is quoted from *Philosophy of Art and Aesthetics*, Tillman and Cahn (Chapter 1 References), p. 379. Excerpts from Suzanne Langer's *Problems of Art* are quoted from *Art and Interpretation: An Anthology of Readings in Aesthetics and the Philosophy of Art*, Eric Dayton, Editor (Peterborough, Ontario: Broadview Press, 1998) pp. 168, 172. Collingwood is quoted from *Philosophical Issues in Art*, Patricia Werhane, Editor (Englewood Cliffs, NJ: Prentice-Hall, 1984), p. 224. Michel Foucault, 'What is an Author?' is included in *Michel Foucault: Aesthetics, Method, and Epistemology*, trans. Robert Hurley *et al.* (New York: The New Press, 1998); see also *The Order of Things: An Archaeology of the Human Sciences* (New York: Random House, 1970). Sigmund Freud, *A General Introduction to Psycho-Analysis* (New York: Pocket Books, 1935), p. 384; *Leonardo da Vinci and a Memory of His Childhood*, trans. James Strachey *et al.* (New York: Norton, 1964), p. 61. John Dewey, *Art as Experience* (Chapter 3 References), pp. 290, 287. Nelson Goodman, *Languages of Art*, 2nd edition (Indianapolis: Hackett Publishing Company, 1976), pp. 259, 265. Semir Zeki, *Inner Vision: An Exploration of Art and the Brain* (New York and Oxford: Oxford University Press, 1999), p. 10; on Calder, see pp. 153ff. V. S. Ramachandran and William Hirstein, 'The Science of Art: A Neurological Theory of Aesthetic Experience', *Journal of Consciousness Studies* 6 (1999) (June/July): 15.

Chapter 7

Walter Benjamin, 'The Work of Art in the Age of Mechanical Reproduction', *Illuminations* (London: Fontana, 1992), pp. 217–51; see 234 (remarks on Chaplin), and 241 (on absent-minded

observers). The 'man of integral awareness' remark is from *Marshall McLuhan: The Man and His Message,* George Sanderson and Frank Mcdonald, Editors (Golden, CO: Fulcrum, 1989), p. 139. The remark on primitive and pre-alphabetic people is from Marshall McLuhan and Quentin Fiore, *The Medium is the Massage: An Inventory of Effects* (San Francisco: Hardwired, 1967) (unpaginated book). For more on Bill Viola, see his *Reasons for Knocking at an Empty House, Writings 1973–1994* (London: Thames and Hudson, 1995/reprinted 1998), p. 71 (Rumi quote) and p. 70 (on artists and technology). Jean Baudrillard speaks of Disneyland in 'The Precession of Simulacra', in *Art After Modernism: Rethinking Representation,* Brian Wallis, Editor (New York: New Museum 1984), p. 262; and of the artworld in *The Transparency of Evil: Essays on Extreme Phenomena* (London and New York: Verso, 1993), p. 15. His discussion of disasters as mere 'holograms or simulacra' is described in Douglas Kellner, *Jean Baudrillard: From Marxism to Postmodernism and Beyond* (Stanford, CA: Stanford University Press, 1989), p. 209; Kellner cites Baudrillard's *Cool Memories* (1987). On an alleged 'refusal of will', see 'The Masses: The Implosion of the Social in the Media', in *Selected Writings* (Stanford, CA: Stanford University Press, 1988), Mark Poster, Editor, pp. 207–19. The 'self-seduction' quote is also from Kellner, p. 148. The Web site by Tim Rollins + K.O.S., *Prometheus Bound,* is at www.diacenter.org/kos/home.html.

Conclusion

Robert Irwin, 'On the Nature of Abstraction', The Dominique de Menil Presidential Lecture, Rice University, 23 March 2000, Houston, Texas. The Sotheby's figures were supplied by Laura

Paulson in 'Art Smart', in *The Book* (Dallas: Neiman-Marcus, April 2000): 100–109 (an article featuring (high-priced) artwork in Sotheby's as exotic backdrop for Neiman's (high-priced) fashions).

Further reading

Chapter 1

Thomas McEvilley has advanced the ritual theory of art, for example, in *Sculpture in the Age of Doubt* (New York: Allworth Press, 1999). Clement Greenberg's views may be found in *Art and Culture* (Boston: Beacon Press, 1961/1984). On the NEA debates, see Richard Bolton, Editor, *Culture Wars: Documents from Recent Controversies in the Arts* (New York: New Press, 1992). On Goya, see Janis Tomlinson, *Francisco Goya y Lucientes, 1746–1828* (London: Phaidon Press, 1994).

Chapter 2

On tragedy, see Plato, *Republic*, especially Book X; and Aristotle, *Poetics*. On the imitation theory in art history, see E. H. Gombrich's *Art and Illusion: A Study in the Psychology of Pictorial Representation* (Princeton: Princeton University Press, 2nd edition, 1961). Also on medieval aesthetics, see Umberto Eco, *Art and Beauty in the Middle Ages*, trans. Hugh Bredin (New Haven and London: Yale University Press, 1986); and Erwin Panofsky, *Gothic Architecture and Scholasticism* (New York and Cleveland: Meridian, 1951). On *Parsifal*, see Matthew Boyden, *Opera: The Rough Guide* (London: Rough Guides Ltd, 1997), pp. 251–4. On Nietzsche's early aesthetic theory, see *The Birth of Tragedy*, in *Basic Writings of Nietzsche*, trans. Walter Kaufmann (New York: The Modern Library, 1968).

Chapter 3

On Chinese gardens, see Maggie Keswick, *The Chinese Garden* (New York: St Martin's Press, 2nd edition, 1986). I recommend the *World of Art* series (London and New York: Thames and Hudson), especially: Robert E. Fisher, *Buddhist Art and Architecture* (1993); Robert Hillenbrand, *Islamic Art and Architecture* (1999); Frank Willett, *African Art* (1971/1993); and Wally Caruana, *Aboriginal Art* (1993). On Huichol art, see Diamond Smit, 'Written in Beads', *Lapidary Journal*, October 1996: 60–5; and, on Inuit art, Ingo Hessel, *Inuit Art* (New York: Harry S. Abrams, 1998). Arthur Danto, 'Art and Artifact in Africa', in *Beyond the Brillo Box* (see Chapter 2 References), pp. 89–114; for a critique, see Roger Shiner, 'Primitive Fakes, Tourist Art, and the Ideology of Authenticity', *Journal of Aesthetics and Art Criticism*, 52(2) (Spring 1994): 225–34. James Clifford, 'Four Northwest Coast Museums: Travel Reflections', in Ivan Karp and Steven D. Lavine, Editors, *Exhibiting Cultures: The Poetics and Politics of Museum Display* (Washington and London: Smithsonian Institution Press, 1991), pp. 212–54. On the Paris exhibition, see Benjamin H. D. Buchloch, 'The Whole Earth Show: An Interview with Jean-Hubert Martin', *Art in America*, 77 (May 1989): 150–9+. On postcolonial identities, see Sunil Gupta, Editor, *Disrupted Borders: An Intervention in Definitions of Boundaries* (London: Rivers Oram Press, 1993).

Chapter 4

Truus Buggels and Annemoon van Hemel, Editors, *Art Museums and the Price of Success* (Amsterdam: Boekman Foundation, 1993). On Thomas Kinkade, see Shaila Dewan, 'Study in Green' (*Houston Press* On-line, 27 May–2 June 1999). JoAnn Wypijewski, Editor, *Painting by Numbers: Komar and Melamid's Scientific Guide to Art*

(Berkeley, Los Angeles, and London: University of California Press, 1999); see also Web site at www.diacenter.org/km/index.html. On museums, see Tony Bennett, *The Birth of the Museum: History, Theory, Politics* (London and New York: Routledge, 1995); Thomas Hoving, *Making the Mummies Dance: Inside the Metropolitan Museum of Art* (New York, London: Simon and Schuster, 1993); Susan M. Pearce, Editor, *Museum Studies in Material Culture* (Washington, DC: Smithsonian Institution Press, 1989); Hilde Hein, 'Museums: From Object to Experience', in Carolyn Korsmeyer, Editor, *Aesthetics: The Big Questions* (Malden, Massachusetts and Oxford: Blackwell, 1998), pp. 103–15. On art and money see Rita Koselka, 'Tasteful, Unprofitable, Microsoft?', *Forbes*, 3 November 1997; Clement Greenberg 'Avant-Garde and Kitsch', *Art and Culture* (Chapter 1 References), pp. 3–21; Carter Ratcliff, 'The Marriage of Art and Money', *Art in America* 76(7) (July 1988): 76–84+; and Carol Zemel, 'What Becomes a Legend Most' (on the Van Gogh auction phenomenon), *Art in America* 76(7) (July 1988): 88–93+.

Chapter 5

Philip Brett *et al.*, *Queering the Pitch: The New Gay and Lesbian Musicology* (New York and London: Routledge, 1994); Nicholas Cook, *Music: A Very Short Introduction* (Oxford and New York: Oxford University Press, 1998), pp. 105–27. On feminist aesthetics, see also Peggy Zeglin Brand and Carolyn Korsmeyer, Editors, *Feminism and Tradition in Aesthetics* (University Park, Pennsylvania: Pennsylvania State University Press, 1995); Christine Battersby, *Gender and Genius: Towards a Feminist Aesthetics* (London: The Women's Press Ltd, 1989); Roszika Parker and Griselda Pollock, *Old Mistresses: Women, Art, and Ideology* (London: Routledge and

Kegan Paul Ltd., 1981). On Jackson Pollock, see Jeffrey Potter, *To a Violent Grave: An Oral Biography of Jackson Pollock* (New York: Pushcart Press, 1987). On Indian potters, see Alice Marriott, *Maria: The Potter of San Ildefonso* (Norman, Oklahoma: The University of Oklahoma Press, 1960); and Barbara Kramer, *Nampeyo and Her Pottery* (Albuquerque: University of New Mexico Press, 1996). For more on Judy Chicago, see www.judychicago.com. Arthur Danto has written on Cindy Sherman in *Encounters and Reflections* (see Chapter 1 References), pp. 120–6.

Chapter 6

On Francis Bacon, see Michael Peppiatt, *Francis Bacon: Anatomy of an Enigma* (Boulder, CO: Westview Press, 1996); John Russell, *Francis Bacon* (London: Thames and Hudson, rev. edn. 1979); and Andrew Sinclair, *Francis Bacon: His Life and Violent Times* (New York: Crown Publishers, 1993). On Foucault and Velázquez, see Joel Snyder and Ted Cohen, 'Reflections on *Las Meninas*: Paradox Lost', *Critical Inquiry* 7 (1980): 429–47. On cognitive science, see also Diana Raffman, *Language, Music, and Mind* (Cambridge, MA: MIT Press, 1995), and Robert L. Solso, *Cognition and the Visual Arts* (Cambridge, MA: MIT/Bradford Books, 1994).

Chapter 7

For more McLuhan, see *Understanding Media: The Extensions of Man* (Cambridge, MA: MIT Press, 1994); *The Global Village: Transformations in World and Media in the 21st Century* (New York: Oxford University Press, 1989). On Benjamin and McLuhan, see Noël Carroll, *A Philosophy of Mass Art* (Oxford: Oxford University Press, 1998), pp. 114–71. For more on Cindy Sherman, David

Salle, Jenny Holzer, and postmodern art, see *Art After Modernism* (see Chapter 7 References). See also Sherry Turkle, *Life on the Screen: Identity in the Age of the Internet* (New York: Touchstone, 1997).

Index